Holding up the Sky

Holding up the Sky

Aboriginal Women Speak

Magabala Books

Olive Morrison's story 'Those Days' was originally published, in an earlier form, by the Aboriginal Studies Curriculum, Education Department of Western Australia, in 1996.

First published in 1999 by Magabala Books Aboriginal Corporation
2/28 Saville Street, PO Box 668, Broome Western Australia 6725
Email: magabala@tpgi.com.au

Magabala Books receives financial assistance from the Commonwealth Government through the Australia Council, its arts funding and advisory body, and the Aboriginal and Torres Strait Islander Commission. The State of Western Australia has made an investment in this project through ArtsWA in association with the Lotteries Commission.

Designer Samantha Cook
Typeset in Palatino 13/14pt
Printed by Hyde Park Press

ISBN 1 875641 43 2

I. Aborigines, Australian - Women - Biography.
I. Title.

305.4889915

Western Australia

Cover Photograph of Tazuko Kaino by Samantha Cook

Contents

DELLA WALKER
Early Days

DELLA WALKER

Early Days

I was born on Ulgandahi Island in 1932. I was reared there and went to school on the island at an Aboriginal reserve school. It was reserved under the Aboriginal Protection Board Act. At the school there was a rations shed where they used to give out food. There was also a little church, a chapel and there was a huge playground at the back of the school. In this playground the boys and girls played hockey. We made our own hockey sticks out of mangrove trees (not mango trees, as they would have been down at the river) and we used to have good games. We didn't have any tennis balls, so we made our own balls out of grass and we tied them up with an old rag. We slogged the ball around and put a bit of dirt into it to make it a bit heavy so it would get better lift into the air. After hockey, we would have a game of football.

There were about seventy or eighty children and about twelve families on the island. The students went up to sixth class. There was no high school in those days. The classroom was

one big class. First class was up at the front and sixth class all sat up the back. The teacher was called Allan Cameron and he was a full-time teacher. He was a returned soldier. As I grew up I found out that they were all returned soldiers on the missions on Aboriginal reserves. Mr Cameron lived on Ashby Island on the mainland side. He had a son Rupert, and a daughter Kathy. We went to his place, where Mrs Cameron used to teach us cooking. Sometimes Mr Cameron would take the boys for a walk over to the side of the hill and go shooting in the bush. He taught the boys how to shoot and how to do general work around the place, doing odd jobs. The girls stayed at the home. They learned how to iron, wash, sew and cook.

It was a lovely little school but I didn't learn very much there. We were told how to read and write. There is one thing I will say about the school, we had our bible reading every morning. The teacher read a couple of paragraphs of the scripture to us each morning and then we had a little service. We used to look forward to it, it was very good. The minister used to come over with some other ministers on Sunday afternoons and have church with us, so it was good. I really enjoyed life on the island at that age, I was about ten.

A Lesson in Obedience

My brother Alan was returning from Kinchella Home in a big red van. He was sent there from the island because he wouldn't go to school. Our sister Annie and brother-in-law had their own property over at Lismore, at Robert White Bridge. When Alan went over there to stay with them, Annie said to him, 'Look, don't go down to the river, I don't want you like old Granny Wheatly.' Old Granny Wheatly was Fuzzy's granny. Annie told him, 'Boy, don't you go swimming down there near the old wooden bridge.' It used to be the old white bridge, not far from Lismore, but today it's a cement bridge. 'Don't you go there because there's a goomboorah there.' A goomboorah wharki is a spirit.

Of course, Alan kept swimming there despite the warnings. Old Uncle George Williams, Uncle Johnny Williams and Abbey Page swam there, but it wasn't dangerous for them because they were from the area. However, Alan was told not to go because he was not from the area. He continued swimming and this kept going on for a couple of weeks. They couldn't keep him away from the river. They kept telling him, 'Don't go there, Alan, don't go there.' Annie started worrying about him too because this 'thing' kept drawing him.

Anyhow, then he started to get sick. He experienced nightmares every night and they kept getting worse and worse. Annie said, 'I don't

know what's going on with this fella.' She rang the police to notify my dad that something was wrong with Alan and asked him to come over straight away. She admitted Alan into the Lismore Base Hospital and whilst he was there he only seemed to get worse.

In the hospital they had him all strapped up but he used to break the straps, as he was a young boy and very powerful. Nobody knew what was wrong with him. Mum and Dad took their babies, Lillian, Mavis and Douglas, to see Alan but he didn't recognise them. He didn't even know that they were his family. This went on for about two or three days while they were over there.

They sent for Grandfather Lefthander, who came from Grafton. That was his name, Grandfather Lefthander. He had been put through the initiation rules. He was a very clever fella. Grandfather Lefthander told Dad over the phone, 'Tell them I'll be there tonight and leave one of the windows open in the room.'

That night when Mumma went to see him there was no change in him. He was lying down ready to sleep, and at about twelve o'clock was dozing off to sleep when a dog came through the window. I don't know how he climbed up through the window because the window is high off the ground, but he said that dog got in through the window. We don't know how he got there. The dog licked Alan's hand then went up and licked him all over the forehead and the face. He licked and licked him.

The next day Alan started to come good and he looked up at Mum and Dad and said, 'When did youse come?'

'Oh', they said, 'we came here a long time ago, we have been here since last week.' He asked them what was wrong and they told him that he had been sick. Alan didn't know what had happened to him but the others knew that he had been caught by the 'thing'. The clever things caught him and these same things exist at Tabulam, for example, over there you are not supposed to swim near the springboard.

They are very dangerous you know, those things. They still exist today. I believe that they still exist. It is a belief of Aboriginal people. It is a part of our culture, you see. Our totem here is the dog. When we used to come from Ulgandahi to go to the pictures and walk along the main road, there was sugar cane all along the road and we could hear this thing running up along the main road but we couldn't see it. I believe it was our totem, the dog. It was ours then and it still exists today. It has always been our strong belief and we were brought up in that way; we were told what not to do and where not to go, and if you didn't listen to the old people you would get into trouble.

Ceremonies

I don't know about the women's sacred sites because Gran was not involved in their

ceremonies. There are differences between the men's ceremonies and the women's ceremonies. Each group has different privileges. Women were told, this is not yours, this is ours, you can go your way, we'll go ours, etc. You know, women were not allowed to mix with men. They used to hold their ceremony separately. Some of the men would stay away for two or three weeks. When they were put through the rules, they were not allowed to be with their women. They were not allowed to sleep with them. It's their values, it's sacred to them. Years and years ago, women and men were not allowed to sleep in the same room, and you see they have still got their Bible ways. The old Aboriginal people hold onto their tradition.

Fishing

When I have a lot of tension I just go out to the riverbank out front and go fishing. I go out there and throw a line out into the river. Whether I get a bite or not, it doesn't matter. When you're throwing a line you get the freshness, just the freshness that's there, and you are releasing your stress. You see, your breathing and freshness starts to come back into you and you feel wonderful. That is just the natural thing for me. That is good for my body.

It was far away at Yamba when it was time to go fishing for the mullet. The mullet travels in April, May, June and July. He travels in the wintertime and travels in schools. My brother

Wallace used to watch for the fish out at sea. He used to keep lookout and the fishermen used to pay him so much to spot the schools of mullets. You could see the schools of fish out as far as your eyes could see. You would see the ripples right out in the still sea. A big area of ripples would mean a big school of mullets. At certain times of the year, the flowers on the trees would reveal when the mullet was plentiful. Some of the fish came inland and they came upriver. There are fishermen still fishing there today, just like in the old days.

Fishing and hunting was a part of us, it was what we wanted to do. The old people used to have a big strong rope like twine attached to a spear that was wrapped around their waists, and when they saw any mullet they would spear them, then pull the fish in with about two or three others on the line. They would get them just like that. The spear would just go through them.

Another way they trapped fish was by building a small stone well on the side of the bank. When the water ran out, the fish would be caught in the well.

When there were sand bars, a lot of sand got washed away by floods and everything was cut through and changed to make the channels. Years ago we used to be able to nearly walk over to the island where Dorothy (Boonie) lived, to get sugarcane, but we can't walk over there now because there is a big, deep blue channel.

Della Walker

Cuisine

There is hardly any grey-face kangaroo down this way but the grey-face is the best kangaroo to eat. He is number one. He lives up Tabulam and Baryulgil way. The grey-face is very sweet and he's got hardly any wild taste about him. There's also the black kangaroo, the red-drum and the swamp fella. You can't eat him because he has a swampy smell right through his system. Years ago, in the wintertime, they used to hang them out to dry and then you could eat the meat about three weeks later. When people were travelling, they would roll the kangaroo meat upon the ashes, bake it in the ashes and then wrap it in something like bark. They rolled the kangaroo around the big outer leaf (not cunjevoi leaves, but other big wild leaf found in the bush) and they stuck it into the hot ashes, cooked it and the bush fragrance would go right through him. After they cut up the meat, they would wrap it in individual pieces and bury it in a big pit that was dug in the earth. When we used to clean a kangaroo, we were taught how to skin him and how to cut him into little pieces. For example, the joints were always number one, but that's what you had to learn. We used to always have the leg or we used to give the tail to other families and say, 'Righto, this is your bit, this is your piece.' It might be the tail, the ribs or the backbone. Some used to take the head off and eat the brain. That was our food and it still is our food today.

Possums are beautiful, they have the gum taste right through them. The hunters used to set traps for possums by getting a long twine and making a wire trap that they would leave at the bottom of a gum tree. When the possum came to climb up the tree he would get caught. Up in Inverell they like to eat the possums when the gum trees are in flower because at that time the flesh has a beautiful taste. The boys from up at home still go hunting and they catch porcupines. They clean them and put them away in the freezer to eat later.

I also make johnnycake—the dry johnnycake with no baking powder which is like Lebanese bread. Today they are making money selling that Lebanese bread, but we had it years and years ago.

Another bush food is cobra. Cobra are wood worms that live in the water, they are big and white. You can eat them raw or cooked with a little bit of salt and pepper on them, and you can have a feed just like that with dried bread. To prepare them, they used to drop them on the coals carefully because their skin is very delicate, like an oyster.

When old people are ill they have a craving for food. When I crave I wish for kangaroo stew or kangaroo gravy with some doughboys, which are like dumplings. That's the way of the Goories. Brought up to eat to survive.

I once went to a high school to show some year 10 students Aboriginal cooking, and they ate all the cobras and all the johnnycake and then

they were looking for more. They were all white kids. It was something new to them and they said, 'By gee, Mrs Walker, that was beautiful.'

Turtles are beautiful too. You see the boys go out for turtles when the big storms come. The storms come around August to the middle of September and it wakes all the animals that sleep. It wakes them and they start moving around and coming out. The turtles come out, the snakes come out, and the goanna. They all start to come out and they are all clean and fat. They are fat because they have been in their holes sleeping for such a long time.

How to cook a carpet snake

Before you cook a carpet snake you've got to gash it with a knife along its markings, and you keep doing that, going around and around so that everything can pass through its body. You then wind the snake around and around until the head is in the middle. Put the snake in the stove and bake it, or cover it over with ashes. When it is cooked, break the head by pulling it forward and off. Leave the fat on the side. The white flesh is like chicken and tastes beautiful.

I have never eaten a black snake. When I was in hospital, a white woman who was in with me said, 'Mrs Walker, I ate snake,' and I said, 'Yeah, what kind?' She replied, 'A red-belly black snake!' I looked at her and said, 'Well, you beat me.' She asked me why I don't eat them and I explained that we only eat the carpet snake and we don't

eat the black or brown snakes because they are poisonous. We only eat the carpet snake, but I can't recall when I last ate a carpet snake because I heard that they are sort of related to a taipan.

The Blue-tongued Lizard

Now you wouldn't believe this, but when John Mercy was a little boy he could not talk. Old grandfather Dick Randall was watching him and decided to go and get a big blue-tongue lizard. It was very long and wide and when he cooked it, it had a very white, clean and fluffy fat which melted in the mouth. He cooked the blue-tongue with his head on, then he cut open the head, removed the tongue and spoke in the lingo. He gave the tongue to John to eat, and this side of a fortnight that boy was talking. He was actually talking. They had to talk in the lingo first, then that boy really started to talk. He has a bit of a murmur now and he still stutters a bit, but that was how he started to talk.

Customs and Beliefs

Years ago, when the old people visited a sacred place that they weren't supposed to visit, they might suddenly get an ailment like a sore shoulder or a constant pain in the ear. Jessie, Lillian, Raymond and Jacky were all caught this way once.

There was a cure for such ailments. The old fellas who had been put through the rules, who

13

had been initiated, would rub you where you felt pain and something would come out of you. This would be long like glass. The old fellas can cure the pain. It is in their hands. The old Aboriginals who were put through the rules were very clever. There was one fella who learnt the rule just for healing the body. They had cures even for cancer. If you can get to the cancer early it can be cured. There are still certain parts in the bush today where some of the old fellas use certain things such as berries, and they add a little bit of whiteman's stuff, such as a bit of salt or something, and this causes your bowels to open. This is all part of what different tribes used to do years ago, but it is still worth knowing and it is important to appreciate and understand the ways of the Aboriginal people. It is very important.

Teaching Respect

When I go to the schools I talk to the children and tell them that it is important for them to have a little respect. They should respect an Aboriginal Elder at all times. I told them if I don't recognise one of them on the street but they know who I am, they should say, 'Good day, Mrs Walker', or, 'hello, Della, or, 'good day, Ma Walker.' I am known in Bonalbo as 'Ma'.

Caring

A young boy who is a friend of mine was in big trouble just before Christmas. I didn't know about it at the time but my son Phillip told me. He said, 'Mummy, you know that boy, he should come and stay with us.' So we took him around with us. He is in gaol now, this fella. He's a white boy but he didn't have a good upbringing, in fact he had a very rough upbringing. The poor kid used to come down because his stepfather used to chase him. He never wanted to return home. He used to come to my place and play with my little boys. They were his friends and when anybody bullied him, like the little white boys who used to get into him, my boys would step in, take his side and bring him home. They always had love for that boy. Now he's in gaol and I don't know what gaol he's in. I'll have to visit him. This is why it is important for me to get a badge so that I can be recognised as a minister.

I am a minister but I want to get a special badge, but I must go through a certain channel before I can get it. I want it so that I can go through the gaols at any time, not only weekends but any time. I want to feel free to go. I want to go into the gaols and visit not only the black people, the Aboriginal boys, but also the white boys too. There are men in there that need to talk to people. Their families might be a long way away, and just by going in there and talking to them you can show kindness. I have been in there a couple of times because we go into the gaol for

the church to meet people in there that have done wrong. You see them just standing there and you know that they are not poor and that they were probably in business before. Just by looking at them you know by their face whether they are basically a good person who may have just done something bad on the spur of the moment. That 'something' happens, and you know that with a bit of love and a bit of care they could be helped. It really does touch me when I see these men in gaol. It hurts, you know, it really hurts.

BETTY LOCKYER

War Baby

BETTY LOCKYER

War Baby

I was born a war baby in 1942, three months after Pearl Harbor. That was at Beagle Bay, the cultural and traditional land of my grandmother.

I was about five years old when I left the mission, but I can still remember events which must have occurred much earlier than my five-year-old memory. I can still picture the 'ration drops' from the army or airforce planes, whichever. One thing I do know for sure, they had propellers. Everyone was running around madly, jumping from drop to drop, dragging them together for pickups. Kids and dogs and all got tangled up in the rush.

The most vivid memory, and the most delicious, was the taste of barley sugar in my mouth. I don't know who gave them to me, but I loved them because they had a strange sweet taste. The only sweet taste I ever had in three to four years was wild honey from the trees. I tried not to finish the barley sugars too quickly. I wanted them to last forever.

Those were beautiful days. How else could I

describe them? Everything was so green, the days were sun-filled, the smell of ti-tree and smoke in the air and family all around. Most of all, to me, my mum and aunties were beautiful young women with waist-long hair, black, wavy and shining. All excepting Aunty Binyu who had short brown hair. I loved them all, regardless of hair colour.

I used to go everywhere with my mum and aunties. They would take me to the enormous garden or fields, where just about everything grew. Rows and rows of different vegetables, patches of different melons and even sweet potatoes. You name it, it was there. It must have been a miniature Garden of Eden. While they worked away in the sun, my little friends and cousins would play amongst the banana trees and coconut trees, pinching tomatoes, snake beans and the like, and whatever else that tasted good and smelled earthy. Sometimes I'd just grab a handful of moist dirt, put it to my nose and smell it, breathing in deeply and exhaling slowly, prolonging the scent or perfume of nature. It was so cool in the garden. I would go there whenever I could, any chance I'd get.

Other days, my aunties would take me to the freshwater springs, looking for lily plants and showing me edible plants and fruit, and how to look for wild honey. They taught me how to eat the lily plants, and other survival tricks which

didn't mean much to me at the time. They told me that if ever I got lost or thirsty, I could just dig the ground in and around Beagle Bay and water would appear.

Some other days, I guess it must have been Saturdays or Sundays, lots of families would go fishing and hunting, or just gather bush tucker, or go on walks in the bush. The fishing spots were a fair distance away, sometimes miles away, but no worries for those people, they'd just pack up and go, kids and dogs, young and old. Walking was no problem to them. Once they made up their minds to go, they'd go, go, go!

On one such outing, my birthday to be exact, my aunties took me with them. My uncles happened to be crabbing that day and left me playing around. Others were fishing. Like any nosey kid, I started copying the young men, poking sticks into the holes, trying to see if there were any crabs in them. All of sudden, I threw the stick away and stuck my hand inside the hole. Something bit me and I let out a big scream, pulled my hand out, and there stuck to my hand was a crab. It had a good grip on me with its claw. They eventually prised it open to free my poor little hand. Everyone made a big fuss of me at the time and were all killing themselves laughing. Even to this day, the remaining aunties and uncles still remind me of the day, still busting themselves.

My aunties lived at the convent with the single women and young girls. When the boys and girls were old enough to go to school, they

were separated from their mums and dads and placed in dormitories. The boys' and girls' dorms were quite a distance away from each other. There were also kids in there who had no mums and dads—no family at all.

The married quarters, where mums and dads raised their children, was called the Colony. The people built their own houses that were made from stone and mortar. In summer it was cool, and in the colder months very warm. Very simple but adequate for their needs.

Children were separated from homes at an early age. From the age of six they lived in a sheltered environment, away from the influences of family and Aboriginal society. That was the only way of life for the Aboriginal children growing up there. The children who did have parents only saw them on weekends, or an evening during the week. They'd all meet near the fence to exchange news, bush tucker or whatever food they could manage to spare. Sometimes kangaroo, emu, fish, or tea and damper. This dividing fence looked like cattle yard fences, which kept animals at bay. This separated the families and children, as well as the missionaries. There was always either a nun or priest nearby, keeping vigil until visits were over.

I learnt that most of the children on the mission were from all over the Kimberley, as well as the southern region of Western Australia. I don't know how often the 'human round-up' took place, but it must have been both frightening and terrifying to the Aboriginal people and their

children. Families and tribes being torn apart and taken by force. Most were only babes! One thing I do know is that the kids I grew up with at the mission, and later on at the orphanage in Broome, were like lost souls, plucked out from loved ones' arms, herded like cattle into holding yards and then dumped with strangers in a frightening environment.

There were a few children from the same camps or tribes, and others who were old enough and lucky enough to be able to tell the other children to whom they belonged, and from where they came. This proved to be helpful and a blessing when it came to the marriage line, for those who remembered their culture, knowing they did not marry the wrong way. For the lost memories and for lost years of the very young, I feel sad and angry that brothers, sisters and cousins may have married each other. One never knows, it could have happened all those years ago. The government of the time may have thought it was doing the right thing by the Aboriginal people, but it proved almost fatal to our race. One must remember that this horrible 'reform' happened all over Australia.

My grandad, Willy Wright, came from Turkey Creek but he was old enough to remember the little ones who were taken from his mob. He used to tell them who was who, how they were related—blackfella way— and from where they

came. He and the other older boys and girls kept that alive in themselves, so that one day they could go back and find their people again. God willing that their mums, dads, younger brothers and sisters would still be alive.

Because I was too young to live at the convent, my aunties used to sneak me into their dormitory to sleep with them. The aunties that I can remember living at the mission were Chrissie (Giggy), Peggy, Philomena (Binyu) and Bella. I was told that my other aunties, Kathleen (Kudjie), Betty and Cissy were living elsewhere. Aunty Giggy would sneak me inside and Aunty Bella would hide me under the bed. Aunty Binyu would keep watch in case Sister would walk in on them. I was one spoilt kid. They would play with me all night, trying to make me talk, laugh and sing until I got tired.

They'd smoke tailor-mades and when they snuck me in to be one of the girls, they would give me a drag. I'd cough and splutter but they'd laugh themselves silly. Because I made them laugh, I thought—That's good, I'll make them laugh again, and I would start again. I'd feel sick after that. Maybe that's why I never took up smoking.

Early in the morning when Sister unlocked the door, my aunties would take me into the showers with them, bathe me, wash my hair and pretty me up. They'd comb my hair and tie my hair with strips of pretty material. Then they'd call out for Mum or someone to get me. Their ritual would go for days until they got tired of it,

but then it would start all over again. I loved it! Another thing that I should mention is that they were very protective towards me, especially Aunty Binyu. Heaven help anyone who touched me or teased me. Aunty Binyu was a mad one, unpredictable, you'd never know what she'd do. She was a real lively one, always playing tricks on anyone. I could just see her now, tossing that head of hers, then laughing.

There was a playing field between the Colony and convent where the boys and girls used to play. One day, Aunty Binyu was playing rounders and on the run to home base she slid and cut her leg on broken glass. Blood was running everywhere, girls were screaming for Sister, and little ones were running back and forth to their parents telling them what happened. Sister came and tied a tourniquet aroung her leg, and asked some of the boys to help Aunty into the clinic, where she was stitched up. Sister did a good job on her, because years afterwards I would still run my small fingers along that scar and remember that day. Aunty said that I had a fine memory. I'd tell her, 'I'm glad you don't hurt anymore, but that scar still looks like a big centipede.'

I loved rainy days at Beagle Bay. Sometimes it would rain for days, causing the gullies to fill, creating warumbas and letting us swim in the running waters. My aunties used to hold me tight, in case the current would sweep me away. I loved clinging to them. I knew they'd never let go of me.

I liked washing days. The coppers would be lit really early in the morning, ready for boiling. The women and girls would be washing away at the big tubs, some poking the clothes in the coppers, others wringing them out and some hanging clothes out onto the lines. Mothers would come and give a hand as well, having been the more experienced as they would have been doing this before they got married.

'Keep away from the fire or you'll get burnt!'

'You big kids, take the little ones and go play under the trees!'

'Don't get into mischief or you'll get a good hiding!'

Yelling and shouting would go on all morning. Sometimes arguments would break out amongst themselves over little things. If it got out of hand, there was always an older woman or sister who'd break it up. Most of the time the kids would go under the trees and play. We'd even go to the church and make a visit. It made us feel holy.

I liked going to the church because there were a lot of frogs you could play with; green ones that lie in wait for you in the holy water fountain, pale ones which they called Our Lady frogs, and dark ugly ones which seemed to live in the oleander trees. I called them devil frogs. As I said before, it sure made us kids feel holy going to the church, gazing in awe at the big holy statues, especially the Blessed Mary and the crucifix. The altar at the church fascinated me. It was so beautiful. No matter what angle you used to look at the

statues, it appeared as if their gazes were following you. That would make us feel special.

'Look, Jesus is looking at me,' I'd say in a low whisper.

'No, he's not! You come here and watch Him. He's looking at us over here!' someone would reply.

We all insisted He was looking at us in a special way. Whenever any of us would be naughty, we would remind ourselves that God and the statues were watching and we'd better behave. 'Remember those eyes,' we'd say. Our parents told us the very same thing and that kept us on our toes.

It was really great being that age, too young to be in the convent and too small to work. We more or less had our own kind of freedom. Playing around and finding out about insects, butterflies and flowers, what made things grow and why they withered and died. It was a kind of early education, but we were finding out ourselves by asking endless questions, and sometimes not fully understanding the answers, but still being satisfied with them.

My mum and the other old girls used to tell us kids a lot of stories about things that happened to them in their convent days. Some were funny, others sad, but we listened to them with a yearning for more stories. A favourite story that was told to me by Mum, Granny Alice and Granny Lena was the day the Japanese planes flew over Beagle Bay and everyone bolted. They forgot about poor little me in the cot, sleeping

away with not a care in the world. When Mum finally remembered about me, she ran back to the house to find me gone. Panic everywhere! They went running from house to house, gathering everyone on their way to look for me. They looked for me in the nearby scrub, amongst the trees and under the bush. After about an hour they found me with my Lulu David, cradled in his arms, baby-talking to him. He had lost his leg in his younger days, but managed very well with his wooden crutches, which he stuck under his arms.

Can you imagine this wonderful man bolting into the bushes with a baby in his arms, just getting her away from danger? When asked why he ran off with me, he answered, 'Well, everyone took off too quick. Somebody had to look after Betty-girl. Those Japanese wasn't gonna get us. I don't know what happened to Aggie. She took off with everyone else.' That made me feel good inside, and it still does to this very day.

Sometimes we'd go into the bush to look for fruit, honey or other bush tucker. The old women taught us what fruit and plants to eat and what not to eat, the poisonous ones and the medicinal ones. They'd tell us stories along the way, true ones and legends of the area, each either funny or sad. Most of all they taught us survival skills. I was too young to fully understand all this, but I remember the older girls listened intently.

Now that I am older and wiser, I often reflect on the past. The things that our grannies were telling us began long ago, before they

themselves existed. That was the way customs and traditions were handed down. They had no pen and paper to record things, so everything was kept alive by the people passing on their history and beliefs to their children, and so on.

Once I happened to look towards the sky and something in the trees caught my eye. I asked my granny what it was. Suddenly I was pulled along and told not to look up there anymore or something would get me. A short distance away Granny Lena told me that was a burial tree. It was still customary to bury the dead in that way. The old people wanted it that way because they never buried the dead in the ground, like the whitefellas' way. She never told me the full story of the burial trees. I never asked her again anyway.

We'd go back to the Colony laden with bush tucker and have a good feed, sharing with the others. No matter who had the most food or caught the most fish or meat, we'd always get a taste of it, even if only a morsel. My people at the mission went on with their daily lives, waking up, going to work and some going to early Mass before work. There was hustle and bustle every morning with fires being stoked up, pots and pans being rattled, and the aroma of hot tea and goat's milk in the air. There was always laughter and happy sounds coming from the open fire areas. The houses were fairly close to each other and exchanges of gossip and loud greetings were common. Even family disagreements and rows were morning topics, but that was the norm and

31

everybody took it in their stride.

The men had their jobs to do, each going to their work place, whether it be the bakery, gardens or tending to the animals. The women stayed at home to look after the small children, or worked elsewhere for a few hours. Some worked at the church or in the convent with the other girls, or in the gardens. When I look back, I see how well structured their lives were, and how well laid out it was for them.

The whole community seemed ordered or summoned by the bell. The bell woke them up, drew them to church, told them to work, when to stop, when to eat and when to sleep. Everyone took it for granted. We all lived by that bell, and what a wonderful, big, loud bell it was. I am forever grateful for that bell, it has made me mindful of time and I respect that. I may be a little slower now, but I am still mindful nonetheless. I will give you an example about the power of the bell.

At twelve o'clock every day the bell rang and everybody stopped. I mean everyone. That was Angelus time and everybody dropped everything to say Angelus. One could be out in the fields, hanging out clothes or just having a drink of water, and when the bell rang he would have to stop, bless himself, kneel and pray. Groups of women, girls, men, children or just individuals simply stopped and prayed. It was just so beautiful. Once, one of the bigger girls lifted me up to grab the rope to pull it so that the bell could ring. I was not heavy enough and found myself

swinging in mid-air. Talk about a laugh!

After lunch, or dinnertime as it was called, all the girls had to have a rest. The big girls had to go to their big dorm and the little ones to the little dorm. They were locked in the dorms, and could either sleep or do the things they wanted to do as long as they did not make a noise. They either read, sewed or did their hair, combing, brushing or braiding. My aunties would sneak me into their dorm for a rest on some days, otherwise an aunty, usually Binyu, would start friending up Sister so I could go in. Because I was a good girl, Sister would let me go with them for a rest.

The older girls had a favourite pastime. I'd notice them using small mirrors to catch the sunlight, and throwing the reflection towards the boys' dormitory—older boys, that is. They'd be signalling their boyfriends. Don't ask me how they'd understand the messages. It was all light and flashes. It was all fun and games anyway. There was no way that either could meet, not with the barred windows and locked doors, but most of all, the distance!

The girls who had boyfriends would be writing letters to them, even though some never got through. They had fun writing anyway and they'd get a good giggle out of them. I think they had a messenger somewhere because a lot of the girls would pass their replies around the dorm for laughs. The love letters would be kept stored in either biscuit tins or cardboard boxes, and be taken out everyday to be read. They never got

tired of the same ritual everyday.

Around two o'clock the doors would be opened and they would carry on with other work or unfinished work, like sewing and ironing. The kitchen girls would go back to the dining hall and prepare the evening meals. Down at the laundry area, I would be fascinated with the old irons they used. Stoves were fired up and the irons were placed on them to be heated. The way the girls handled the irons was a sight to see. Dashing from stove to table, then quickly ironing the garments in case the iron would lose the heat and make it difficult to press the clothes properly.

The girls and women laundered and ironed tons of nuns' habits and other religious clothing. All white, bright and starchy. All this was done by hand. They never had washing machines, but nonetheless the habits and garments were so white and spotless. I can almost smell the cleanliness and starchiness now. I never thought that electric irons, like today's, would ever replace them. The girls were taught to sew and make clothing of frocks, underwear and children's clothing.

Every year before Christmas, dress material and the like was purchased and there would be a mad flurry to get clothes made for Christmas parcels, which were handed out for that occasion. The girls even made their own wedding and bridesmaids dresses, as well as other accessories. They were all beautiful outfits and the wedding parties would look gorgeous and handsome. You don't see full-blood

Aboriginals getting married in white wedding gear anymore (at least I haven't). It's such a pity because they make a beautiful picture. I wish I could have taken photos of them.

Broome

Down the marsh where we lived with Uncle Jacob and Aunty Kudjie, there were four houses built on stilts. We lived in the house with the highest stilts. They were built on stilts because the high tides would flood the marsh basin, which in turn would overflow into the streets, shops and houses. Some houses would have sea water coming up through the floorboards and doors. The Sun Pictures would also be underwater.

On pictures nights when it was big tide, people would wade out onto the streets to higher ground. Husbands and boyfriends would carry their ladyloves, and little kids would be crying and grizzling because they did not want to step into the cold water. The Roe kids were lucky because their dad or older brothers would have a dinghy waiting to take them home. Not like us, poor things, we had to wade back home in the dark.

During the day when it was big tide, we'd dive from the windows and steps straight into the swirling waters, having the time of our lives, yelling and screaming, ducking and diving, holding our breath and swimming underwater.

We'd also fish from the windows, catching whiting and small bream. Other people would try catching fish with their nets. On weekends we'd beg our mums and dads to let us go swimming down at the big jetty. Big jetty (jetty at Town Beach) was taboo for us. Our parents had to take us themselves or with trusted people. Never would we be allowed to go there by ourselves.

'No,' they would say, 'it's too far away and no one will be there to look after you. If you kids want to go swimming, go to Streeter Jetty. At least there'll be plenty people there.'

Streeter Jetty was the small jetty which the luggers used for refuelling, picking up stores and equipment, and when the crew got off for a spell from the sea. We loved swimming down there. Most of the Chinatown kids swam, fished or just plain played there. Even when the tide went out we'd play on the beach or in the mangroves, looking for bugulbugul or mudskippies, sea snakes and cockles. We didn't play in the mangroves when it got dark for fear of the goonboons—scary, hairy creatures who loved to eat kids. They were ugly and short. We never heard of big tall goonboons.

Most of us kids were fortunate to live in Chinatown. By that, I mean that there was a conglomeration of nations—Chinese, Malayans, Indonesians (mostly Koepangers), whites, blacks, half-castes and quarter-castes. I kind of learned a lot off these people, by mixing with their children, I learnt about their lifestyle, their

culture, tradition and religion.

The Aboriginal kids in Chinatown, especially us relations, liked mixing with the Chinese kids. Most of their parents owned shops and felt sorry for us by giving us heaps to eat when we played with their kids around the back of the shops. Most of them owned restaurants or small general stores. They also knew our parents because they all played cards together and gambled their money and time away. Everybody knew everybody in Chinatown.

There were two big stores in Chinatown owned by white families. They were Streeter and Male, and Kennedy's, and they faced each other at the opposite ends of town. There were a couple of Indian (or Ceylonese) shops, and quite a number of Chinese shops and restaurants. There was one picture show, or theatre, called the Sun Pictures, a bakery, butcher shop, hotel and an old ice factory. Hardly anyone had electric fridges in those days.

We had an old icebox or what they called a Coolgardie fridge. Sometimes we were sent to pick up the ice from the factory. We pushed an old cane pram all the way up the streets till we got to the place. Then we had to push the pram all the way back. Sometimes we'd get talking to the other kids and would forget that we had the ice. Oh well, better to have half blocks than none at all, we thought. Other times when we forgot, we'd see Uncle Jacob or Uncle Johnny coming for us. That made us scatter and we'd start running with the pram. Our family needed that

ice but we never thought about that.

Even when we were sent to get bread, we'd do stupid things. The bread would be hot and smelt wonderful, especially the golden crust. Walking back home we'd slowly start picking the crust and eating it, making a small hole in the bread, which was getting hollowed out. By the time the bread reached home there was hardly anything left. We'd either get a good growling or wallop, depending on the mood. On top of that we were made to go back and get some more. I loved eating the hot bread with butter melting and smothered with honey or Vegemite. When any of us kids had to cut the bread, the slices were about an inch thick, but it was yummy.

Sometimes when we were told not to go to the big jetty to swim, we'd head for Streeter Jetty and have a little swim. It wouldn't be long before someone would say, 'Let's go to see if Sally or Doris is at the big jetty,' or 'You know what? I heard that a passenger ship is in port. Let's go and see if it's still in. We can have a swim there as well, and when the tide goes out, we'll be able to see the ship lying on its belly in the mud. All the gang will be there.' Any excuse would do, and we'd be off in a flash, paying no heed to our parents' warnings. All we could think of was our friends and the good times. We didn't wait for our bathers to dry, we'd just pull our clothes on and we'd be off.

It would have taken us about an hour to get to the big jetty, but the times seemed short when we told stories or when the boys would use their

bamboo spears to spear mullets or gardies. Charlie and Tony were straight shots, hardly ever missing their targets. Quite often we'd meet up with other kids heading in the same direction. Aggie and I would get into little arguments about film stars or who we chose as our friends. I didn't like some of her new friends or she didn't like mine. She'd say that Van Johnson was so handsome, and I'd say Gene Kelly was better looking. On and on it would go about different actresses and actors, and thank God they were friendly arguments because Aggie was the only girl cousin close in age to me, so we were always together.

When we'd get to the forbidden place, we'd start running, pulling off our tops and shorts, and dive straight into the beautiful blue, cold sea. We'd come up for air, looking for Doris, Sally or Maureen and the others. As soon as they were spotted, we'd swim to them. Time was lost to us. We'd swim the length and breadth of the semi-circle shark-proof swimming enclosure. We'd swap news, gossip, make fun of our 'enemies' and watch older teenagers skite around. When it got too cold, we'd scoot up to the hot white sand and roll ourselves in it trying to get warm. You could hear our teeth chattering. After a while, we'd head back for another swim. This went on all day until we decided to go home. Other times we'd swim until our feet and hands got wingema, wrinkled, from being in the water too long. But we didn't care.

When the big ships berthed, we'd forget

about swimming and head for the big jetty. No one was worried about the distance we had to walk. To us it looked five miles long, even though we knew it wasn't. We'd have to walk all the way to the end of the jetty, walk all the way back to the swimming area to pick up the other kids, and trudge all the way home. We didn't seem to mind. Distance did not bother us. We just walked everywhere.

When we'd arrive at the end of the jetty, we'd watch the passengers come down the gangway with their luggage, umbrellas unfolded to ward off the harsh sunlight, young children pulling at their mothers' skirts and babies laughing—happy to get off the ship, I'm sure. There was hustle and bustle, pushing and shoving, wharfies yelling abuse to each other, and us getting in the way of everyone. Sometimes we'd recognise the local people on the ships. Probably coming home from holidays. We'd see new faces, which would become familiar to us over the next few months: bank johnnies' families, PMG families, or the likes of other government department staff.

Usually the pearling masters would take their families down to Perth by ship and return the same way. It was a kind of status, I think. It wasn't as if there wasn't any air service available. Even if there was a chance for me to travel by ship, I'd never do it. I had the opportunity once to go aboard a passenger ship on a casual tour with several other children and was not impressed. I felt that everything was closing in on me. The cabins looked too small, and the rolling of the

ship made me sick. I was glad when I got out.

The best time was when the crew called out to us and started throwing us fruit by the bucketful—apples, oranges, bananas, pears or whatever they had. There was a mad frenzy. White kids and black kids were pushing each other around to jump for the goodies. We'd all share the fruit around, then go and eat them under the jetty on the platform. It's a wonder no one fell into the sea. I think the crew had a great time too, knowing we'd appreciate the gifts.

There was a public telephone on the wharf. We'd scrape up a few pennies to call anyone who had a phone. Sometimes we'd just chat to the operator or coax her into putting us through for free. We'd tell her we'd pay her back next week, but next week never came. I think she knew that but she just humoured us. When it was time for us to go home, we weren't too cheerful. It was all gloom and doom. We were scared knowing what we'd cop when we got home. We could never lie when asked where we had been. It was pointless anyway because our parents always knew when we disobeyed. Of course we were punished for it. We'd start crying before we'd even get in the door.

We'd all get a good whacking on our legs, one by one. We'd dare not run away from the punishment, 'cause we'd cop it harder when we got caught. It was a funny sight with all of us yelling, 'Mummy! Mummy! Mummy!' in turns. We never seemed to learn, nor did we look forward to the punishment. It wasn't that we

were really naughty kids, it was a way of life with every kid that did that, and we'd talk about it to whoever listened to us.

One day during lay-up season, I went with Aggie and Charlie to Streeter Jetty for a swim. I was diving from the jetty and swimming around. It was big tide too, with the water coming up over the jetty. It must have been a foot underwater. When I got tired, I walked up the beach to sit down. After about half an hour, I noticed the big kids swimming under the jetty and coming up on the other side. It looked easy so I decided to have a go. I could swim and hold my breath just as good as them. So I went back into the water.

I took a deep breath and swam under the jetty. About halfway I must have thought that I was out the other side. When I came up my head struck the planks and I panicked. I tried to duck again and dive out but I kept striking the planks. My lungs were bursting and I was thinking, I'll drown! I'll drown! It seemed like years that I was down there. I was kicking and waving my arms about like a madman. I was thrashing around in a frenzy. Suddenly I felt a big hand and arms around me, pulling me away and upwards. I was breathless and gasping for air. I couldn't talk. I just dropped like a limp rag.

'You alright? You alright?' a man asked. I could only nod.

When I calmed down I saw that it was Uncle

Raphael Clement. He said that he was watching us swimming and playing around while he was taking a break from work. He saw me dive under the jetty. When he saw that I didn't come up, he ran over, jumped into the water, dived under and pulled me out. That was a close shave. Thank goodness for people who watch over kids, even casually. After that incident, I never tried that stunt again. It frightened me for life. Sure, I still swam there but with caution. It was the thing to do in those days.

Life would be pretty dull without Streeter Jetty. It was the hub of life. It was so busy down there. People going this way and that, working on the luggers or at the shell shed, loading up crates of shells or just talking and laughing. Sometimes the men would give us a ride in the dinghies and take us on the luggers, where we'd dive into the water and swim. There were lots of sea snakes around but no one cared too much about them. That didn't stop us from swimming. We never felt scared of the people down there. They were a mixture of races but it was nothing. To us they were people. Our mob worked amongst them too, so it made it even better. They all worked together, spoke a common language— Malay—and just got on with their work. Everyone spoke Malay because it was an easy language to pick up. Even our mob learned to speak it. Anyway, it was a good, simple life and everybody lived it that way. Well, so it seemed to us kids.

The kids of Chinatown were a mixture of

Chinese, Ceylonese, white, Aboriginal, half-caste and quarter-caste from either white or Asian parents. The white kids of Chinatown were from white mothers who lived with the Indonesians or Koepangers. They were referred to as the Melbourne women. Most of the Melbourne women seemed nice, and got along well with the Aboriginal women who took Asian men for their husbands too. It was said that the Melbourne women were from poor families and broken marriages, and that they followed their men for a safer and better life. Perhaps the idea of living in a flourishing pearling town in the tropics infatuated them. I don't know. For sure, it must have been better than living in a cold and wet climate, especially if you were poor. I couldn't imagine white people being poor like us, but they were.

The white kids were OK, a little older than us, but we took no notice of them. There were only about two or three girls close in age to us. I found through visiting these girls that they had plenty of clothes, shoes, toys, and most of all they had lots and lots of jewellery. Real gold, precious stones such as diamonds and rubies, gold chains, rings, pendants, bracelets, brooches and earrings.

One of the girls, Betty Marwon, used to let us play with her toys and dress up in her and her mum's clothes. We'd paint ourselves up with make up and prance around in high-heels. We thought we looked gorgeous, but in reality we looked silly. Once she even let me wear her jewels. We played all that day in her jewels and

clothes. In the afternoon, I changed back into my own clothes and took off the jewellery. Then I went back home. When I got back home, I noticed that a gold ring was still on my finger. I told myself that I'd take it back in the morning as it was already dark. I'd tell Betty that I had forgotten to take it off. I didn't want to walk back in the dark.

It didn't turn out that way. It was out of my hands. That night my finger swelled up. I was in agony and was too frightened to tell Mum. She'd have clouted me. After a while, it got too painful and I went crying to Mum, showing her the swollen finger where the ring cut into my flesh. She tried in vain to use soap to get it off. Finally she took me to old Mr Ellies, the jeweller, who cut the ring off. Such relief! Mum never let me forget that incident.

The next day she took me to Mrs Marwon and explained everything to her. She made me apologise, and offered to have the ring repaired and paid for. Mrs Marwon told us not to worry about it. She'd see to it herself. She said that I could still play with Betty whenever I wanted. Maybe Mrs Marwon felt sorry for me because my mum was living with her husband's countryman, another Koepanger by the name of Ala Dia. Those people respected each other, and Mum must have felt no good about it, thinking I must have stolen it. I tried to tell her I did forget it—truly. She said that I made her and Dad feel shame. That made me feel guilty, even though I knew it was a mistake for not taking notice.

The Chinese kids who were our good friends were the Fong-Sam kids—Glenda, Phyllis, Chester, Terry and Wai-Lin. The others were too young and used to get in the way whenever we played. Everyone called Mr Fong by his first name, which was Willie. So did we, but we always called Mrs Fong just plain Missus. They were very good to us, especially Missus. She was always kind to the Sesar kids and me. She fed us well whenever we went there to play. Chinese food was heaven to us. We felt very sad when Missus went away. We never saw her again.

We used to play marbles on the footpaths or down the marsh. I was not a very good shot and lost most of the time. Aggie and Charlie were crack shots and beat most of the kids. The pearler's son, Kim, used to come down the marsh and play with Charlie and the other boys. We paid no heed to him. He was just another white boy. He got on well with the boys though. He had a smaller brother, who came with him sometimes.

There were times when we all hung around the picture show during the day, when it was shut. It had a verandah-type porch and steps. There we'd act out the parts of Robin Hood, Sinbad the Sailor, Esther Williams, or anyone who took our fancy. There'd often be fights in deciding who we'd be.

'I bags Judy Garland!'

'You can't sing or dance.'

'I bags Shirley Temple!'

'You haven't got ringlets.'

'I bags John Wayne!'

'You can't shoot straight.'

On and on it would go. We never got sick of those games.

Just around the corner from where we lived was the Sun Pictures and Chinese shops. The most frequented one was Ah Ming's or Anawai's, as he was called by everyone. He let people book down food and things, and they'd fix him up on pay days or if they happened to win in cards. We'd book down lollies, biscuits and soft drinks to our parents. Whenever we were hungry we'd head for Anawai's. We'd go on a spending spree. If it was stone-fruit season, we'd book down apricots, plums, peaches, grapes and whatever else was available. Sometimes we'd overspend but the bill was paid promptly. They were satisfied as long as we didn't buy cigarettes and other rubbish.

One trick amongst the kids was covering pennies with silver paper to make them look like two-bob pieces. One kid would bang on the counter with the fake two-bob piece calling out, 'Anawai! Anawai! I want to buy olangee. You got any olangee floot? Hully up! Hully up!' Most times he'd be sitting down the back. As he'd come shuffling up one aisle, a couple of kids would go down the other aisle and start filling their pockets with goodies, biscuits or a couple of bottles of soft drink. The kid up front would keep him occupied by haggling the prices of different things or he'd say, 'This olangee is too small. Can you get me a bigger one?' When Anawai'd shuffle to the back of the shop, the other kids

would sneak up the front and out the door. When he'd get back to the counter, the kid would pay him with the fake coin and he'd put it in the drawer. That seemed to work most of the time. Other times when he woke up to the trick, he'd tell the kids, 'You kids no good. I tell mummy daddy. I catchee next time!' He never did though. I think he enjoyed playing the game himself. No one thought of it as stealing. It was like a dare game. Any of us could have booked things down if we were hungry.

Poor old Anawai. Sometimes we'd call out to him, 'Anawai, run away! This way, that way,' repeatedly, bursting out in laughter.

He'd come out shouting, 'What you want! What you want!'

'You got flootee? Olangee, plummee, glapee? Gimmee lolly, Anawai. Please, Anawai. We'll pay you tomollow.' Sometimes he'd give in to us, other times he'd just walk away, shaking his head. He must have got sick of us.

Another old Chinaman we used to visit was Ah Kim. We'd go around the back of his long-soup shop and talk to him, watching him make the noodles. We were fascinated with the cutting machine and would watch him hang out the noodles to dry. We'd also beg him for the leftover dough to play with. We'd talk to him, asking him all sorts of questions but he'd just nod and keep on smiling. I don't think he understood a word we said. On the other hand, he may have been too clever for us and just played ignorant.

We'd all agree though, he made the best long

soup in the world. Just about every night we'd go and have long soup and satays. If we helped him during the day, he'd give us free long soup that night. People said that he made the satays from the stray cats in Chinatown, but we didn't believe the stories because we'd watch him prepare the satays and help him skewer the meat. On 'free' nights we'd all turn up in full force.

Round the back of Ah Kim's was one of two gambling houses. This was Baldhead Taylor's place. He ran chiffa as well as card games. Chiffa was a kind of lottery which everyone played. It was run twice a day, at noon and evening time. It usually paid good dividends, better during lay-up for there would be more people around. Even kids had a bet with their one shilling and two shillings, trying to win picture money.

Every day after the midday draw, people would come outside, talking a mile a minute. The whole of Chinatown would come alive. When they'd see a chiffa man (a kind of bookie) they'd call out, 'What come out, what come out?'

The chiffa man might reply, 'Tiger come out, tiger come out.'

'How many people catch him?'

'Might be four, five people.'

'How much pay?'

'He pay ten pound. Good 'nough.'

The same thing happened at the evening draw. That was part of Chinatown's life beat.

Even when I grew older and moved out of Chinatown, my mum used to make me sick when she'd ask me to hop on the bike and pasang two

pounds on dog/rat. Most times Mum was running late with her bet, and I knew I'd really have to move on that bike, otherwise I'd never hear the end of it, especially if it did come out dog or rat! If she did miss the draw, she'd say, 'See, I knew it would come out dog. I had a good dream last night,' or 'I had a good kinduk this morning.' Bets were usually placed on hunches, dreams or on certain 'visions' that they happened to see that day. The other game they played was a Chinese game called kaja kaja, or four card. The small oblong sticks or slabs had numbers on them, something like domino slabs. Anyway, people played big money on that game.

Everyone got happy when the luggers came in because they had a chance to win big money. The Chinese men, and later the Japanese, were big-time gamblers and would hold the bank most times. To hold the bank, one would have to put money up front to cover the bets. Most bankers would just declare that the bets would be covered by starting, that they would play 'pocket' money or 'no speak' banker. They were taken on trust. If ever one would renege, you could bet all hell would break loose. So they usually played by the rule. Sometimes the game would go on for forty-eight hours or so. If the bankers were losing, the word would spread like wildfire. This was a chance for the people to win big money from the bankers.

Mr Dep, who owned the tailor shop, ran the bigger of the two gambling houses. Children weren't allowed in these, but on occasions we'd

sneak in there to see if our parents were playing, hoping they'd win. Our eyes widened when we saw all the tenners and fivers floating around the table, and the tong box filling up. We all knew gambling was illegal, but somehow the Asian dens were allowed to operate. Perhaps the police turned a blind eye, seeing there was no disturbance or harm being done. Or perhaps they saw a need for occupational therapy.

How come then, the police always raided the card games that the Aboriginal people ran? Up the hill ('Indian Territory'), down the marsh at the running water, council yard, or wherever they happened to play, they always seemed to get raided. There was no disturbance or harm being done. Maybe the odd drunken fella would come humbugging for gurry (drink) money, but that's all. So why? Maybe the police needed an occupational hazard for their own occupational therapy?

When our mob saw the cops pull up, they'd hide the money quickly goes, but would keep on playing, taking no notice of them. They'd be whispering, 'Yor yor, Linjoo!'

One cop would say, 'OK, where's the money?'

'What money? We got no money!'

'OK, what game are you playing then?'

'We're playing bridge.'

'Don't look like bridge to me.'

'Well, this is our own bridge, our own game.' (Aye girl, as if Mum and them knew how to play bridge.) Sometimes when they felt like it, the cops would confiscate the cards. Poor things! But soon

as the coast was clear, out would come another pack of cards.

I was told this story that happened just after the war. This day the gamblers were caught red-handed, 'cause there was no one to warn them. Usually someone would keep watch, or even the children would keep an eye out. They were all sitting down smoking, playing, drinking tea, babies swinging on nyanyas (breasts), busily sucking away, and constant fun-talk, which was Broome-style. If someone went bucking, there'd be a big laugh. If one made a mistake, one would never hear the end of it. They'd keep it up all day and night, teasing that poor man or woman. Before they knew it, the cops were there in the room.

'OK! Stop right there! Don't anyone move!'

'What's your name? And yours?'

'Come out of the kitchen. I can see you there!'

'Put all the money in the bag!'

'Pick up the cards and blanket!'

'Don't forget the table and chairs you're sitting on.'

'You all better start walking to the police station with all the evidence.'

The men, women and children trotted to the police station, carrying table, chairs, blankets and other evidence. People on shop verandahs called out to them good-naturedly, some teasing, some feeling sorry for them. They stayed in the cooler for a while, until they were duly charged and released. My granny was one of them. The oldies still laugh and talk about that day. That didn't

stop them playing cards at all!

That kind of humiliation and degradation of Aboriginal people should not occur in Broome, or any other town for that matter, in this day and age. I think that it was the spirit and humour of Aboriginal people that never daunted their living the way they wanted to live.

I loved going to cards with Mum. She only took me to our gambling places, not the big gaming houses. Most games were held at friends or family homes, so we could play with other kids or cousins. The best place was 'Indian Territory', where all of us would play cowboys and Indians, hiding amongst the small trees and rolling down the big hills with their steep slopes. The only part I hated was climbing back up the slope. It was so tiring for our little bodies.

OLIVE MORRISON

Those Days

OLIVE MORRISON

Those Days

I was born Olive Morrison in Katanning on 2nd January 1919, in a tent by the saleyards. Granny Spitty acted as midwife, and she came as a favour for Mum when she had me. The rest were born at the hospital. I was second in a large family and Arthur was my older brother. After me came William, Jane, Edith, Audrey, David, Luke and Gertrude. William died in his thirties and baby Gertrude died at eighteen months when we were at Moore River Settlement. They were moving a big safe cot and dropped it on her. Sister Beeck told me she'd gone to heaven. They didn't have inquests in those days.

My mother was Nellie Orchard and she came from Sandstone. She was half-caste but very fair. I don't know much about her parents except that her mother was a full-blood and her father was a white miner who was working for Sandstone. My dad was born in Katanning. His name was Samuel Morrison but his real father was Dave Penny, so he was really a brother to the Penny boys. William William Morrison was a full-blood

who was living with his mother, and she daren't tell him that my dad wasn't his, in case he killed Dave Penny. 'He's my Samuel,' William used to say, and brought him up as his own son.

When William William was old, he had a camp out Badgebup way where they found the gold. I remember seeing him standing up by the railway line with his spears. I was only a little girl then.

Dad married Mum in the church at Carrolup, and when we were little he worked for Phil Crossley, clearing and burning. We lived in tents, one for the boys, one for the girls and one for Mum and Dad. The beds were made of two forked logs with split logs along. You cut open wheat bags to cover the boards, then put a mattress on top. Our cupboards were made of split logs and the table was bought off a farmer. It had solid legs and a white scrub top. We had to carry water from the dam in buckets and had canvas bags for drinking water.

To keep ourselves clean we had two galvanised-tin wash tubs and four buckets. We made a fire at the side of the dam and put the buckets on it. Our pegs were made of twisted wire and the clothes were hung on the wire to dry. We had four flat irons for the ironing. I'd stand them against the fire, and iron on the table. I used to iron all the kids' clothes after school, ready for the next day. We had galvanised-tin baths for us to bathe in—one big and two little. We washed our hair with Velvet soap and cleaned our teeth with Gibbs toothpaste. Not like they have now,

that stuff in tubes. It was round and hard, like soap in a tin.

We never used the old language except a word here and there. Mum didn't talk the language at all, only our language (English). Dad had the language and he used to talk it to Granny Mourish but they wouldn't tell us what they said. They used to talk and laugh but they wouldn't teach it to us. She wasn't really my granny, she was my dad's aunty but we called her Granny Mourish.

My grandfather William William was a full-blood, and he lived with my real granny. Her name was Maggie but I can't think of her last name. Mr Piesse used to keep a record of everybody and he had it written down in a book. I saw it once—he wrote down all the details of people.

I visited Granny Mourish a lot. She was a Penny and married to Eli Mourish. Eli looked like a whitefella and was very independent. He bought a house down by the creek and they lived there. Sometimes I used to go and stay there. Granny Mourish was frightened of the people in the camps—they were always fighting. They'd even set fire to each other's tents. She used to sleep with a shotgun under the pillow.

When Granny Mourish got old, she had a humpy under that great big pine tree by the meatworks. After I came back from Northam, she got very sick and I used to go and sit with her. She wouldn't have a doctor near her and wouldn't hear of going to hospital. She went into a sort of coma and lay there for two weeks before she died. I used to take care of her. She was buried in the cemetery,

and later on they buried her daughter Mabel in the same grave.

Dad was very strict when we was kids. We had to get up early and Arthur made the fire while I cooked the breakfast. 'Don't wait for me and your mother to do things, you're big enough to do things for yourself,' Dad used to say. Sometimes we'd have to cart water. That was heavy, hard work. We had to do it though. Not like kids now, they won't do anything. Too lazy. If we didn't mind, he'd take his strap off. You'd get the strap double if you were cheeky, or played with cheeky kids.

Dad wasn't scared of the dark. He'd go out at night and not worry a bit. I was never scared either, but my brothers were. I remember once he tied them up out in the dark. They screamed and screamed. After a bit Dad went out to them. 'What are you screaming for, did you see anything?' They just kept on yelling. He said, 'There's nothing in the dark to be afraid of. You're just afraid of your own shadow.'

We were all a bit scared though when the full-bloods came from Laverton. I was about nine or ten. The police from Kalgoorlie brought them in a truck, and police came from Albany and Perth. They camped up at the rifle range and came to do some dances. They said they could turn themselves into emus, and the police and whitefellas said they couldn't. Dad took us all up there to watch, and there were mobs of white people there too. The police were right behind the full-bloods, watching them all the time. They

were all painted up. There were two women with them, and one really old fella, strip naked he was. The women made a mia-mia for him and he stayed in there. Dad wouldn't let us look at those full-bloods. He said they were dangerous and we were frightened of them. But it was alright to watch the dances. It was bright moonlight, clear as day.

The first dance was Fishing for Whales. They had a rope, and the way they did it the grass looked like the water. They were pulling and pulling on the rope, and then they speared the whale. All the grass was moving, just like the sea.

After that they did the Emu dance. They did this dance round the trees and were just like emus. You could see them pecking the nuts off the trees, like the emus. The police were going round watching them, and then all of a sudden they just vanished! No one could see where they went. They just vanished and turned into emus over the other side of the clearing. Everyone was looking for them.

Dad made us go in the tent then, out of the way, but he woke us up later for a feed. The police reckoned they couldn't do it, but they did. It was bright moonlight too. Noongars couldn't do things like that, they didn't know about those things.

I started school at Mein Mahn when Miss Daisy Page was the teacher. It was a weatherboard

building same as Cartmeticup, with one big room. All the school buildings were like that, with one room and one teacher. The children were divided into grades and all learned together. There were wash basins in the little porch with tap water from a tank. The teacher had a little room too, as an office.

That first school, Mein Mahn, was on Mr Arthur Hobbs' property, just by the end of the road. Walter Quartermaine's children used to drive in a sulky to school—one horse pulls a sulky. Soon after that I went to Cartmeticup and mostly went to school there. I liked school. I never missed, rain or shine. I used to go sopping wet, but I wouldn't miss. The teacher was Miss Kemble. Her father was a blacksmith in Kemble Street. It was named for him, I think. They were nice people.

Ida Black was at school with us. It was a mixed school with a big mob of Aboriginals. After we moved over near Wrefords, near Keeleys, we still walked to the same school. Mrs Keeley had a little cart. (Betty was the eldest, I think.) If she came along she'd give us a ride to school.

Dad went to school where the Historical Society is now, in Taylor Street. A lot went there and learned to read and write. He just learned to write his name, that satisfied him.

When I was at Moojebing, I used to help one wadgelah [white person] do his sums. He'd get out quick at lunchtime and give me his pencil and paper. 'I can't do them, you put the answers

in for me,' he'd say.

I used to fill them in for him. 'That's cheating, you know,' I used to tell him. 'You should do them yourself, they're easy.'

'I can't do them, you do them.'

Sometimes I did the same for another wadgelah and he was in a class higher than me.

When we went to Woodanilling school a man used to come to teach us scripture. At Cartmeticup we had Christmas sports and a Christmas tree. I started Sunday School when I was at Moojebing school. Mr Judd was the teacher there. Across the road lived Mr Bugg and he never missed teaching us Sunday School. I was about twelve then. I liked Sunday School. They asked questions and we put down the answers. We read the Bible and got homework. We sang hymns too.

I went to different schools because my dad worked on farm properties, clearing and burning. We went to whichever school was nearest. We weren't late for school because Dad had a watch. He used to mark the ground with a stick sometimes, and we could tell the time by the sun on the mark.

As soon as school finished we were out in the bush. We used to drive kangaroos. We'd call out and hit a tin and they'd get driven out into the paddock. Men would be there to shoot them. I only saw one native cat all the time I lived in the bush. The Hansen boys shot it. I saw an anteater once. The boys killed that too and pegged out the skin. Don't know what they wanted that for. There were a lot of foxes. I used

to trap them and take them to the Road Board. We'd get five shillings, head and tail. We used to get a lot. They used to get after the chickens and lambs.

We ate a lot of meat in those days. We got sheep from the boss. Dad would kill and cut it up. We used to trap beautiful fat rabbits too. We'd sell their skins and get a good price for them. We'd get kangaroo but we couldn't get possum, only in the season. The rest of the time they were protected. Dad used to burn off the outside, clean the inside and put salt and pepper in. Then he'd put it on a sharp stick and cook it in the ashes, or make a stew—that was nice done with onions and potatoes. Our meat was kept fresh in a Coolgardie safe, standing in a big bush shade made by the family. Butter was kept in a clay-pit. Dad made a clay-pit in the ground. He put the box in and covered it over. Water would soak through and keep the butter hard.

There weren't any shops near us and we had to order our stores. We'd write the order out and give it to the boss. He'd ring it through to the Woodanilling store. Mr DeBell would send it out with the mail. Dad would buy a hundredweight of flour, sack of spuds, a big lot of onions, big pumpkins, baking powder, and a box of butter— about six pounds.

Mum made our bread with baking powder. It came out nice and spongy. She never used an oven. Dad had a kerosene tin with the top cut off. She put the bread tins in that and then in the clay oven. The Road Board made that for the

workmen. They cooked their bread in it while they were making the road. When they moved on, they left it for us. It was about three to four feet high and round like a beehive. It must have had three tin sides and a tin top to start with. It was all lined up with thick clay and round on top. It went down into the ground a bit. You burn a lot of wood in it, logs and that. When all the clay is really hot, you scrape the coals out and put the kero tin in. A big sheet of tin in front keeps the heat in. Dad used to pull the bread tins out, it was too hot to get near.

I used to make Vegemite sandwiches for school. I made them for Arthur, Jane, Will and me, but they'd go so far, eat the sandwiches and wait up a tree till school was over. They got hiding after hiding but they wouldn't go. I went. I loved school.

After my dad finished at Crossley's, we moved to the reserve at the back of Moojebing Hall. I went to stay with Vera Diamond so I could finish school at Woodanilling.

Once, when I was about ten, my aunty bought me a new pair of sandals. They were the first shoes I remember having on my feet. Most kids went barefoot then. I used to hide them from the other kids, so they wouldn't wear them.

We didn't have things then like we do now. Didn't have fancy clothes or food then, but we didn't go hungry. I remember when the fruit was

in season, we'd go out in the bush and get lots of quandongs. And sometimes we'd get cumuck. It grows on vines out on the hillsides, a long thing like a little bean. We'd go with cups and pick them. There's only one bush down by Broomehill way now that I know of. They had little seeds like raspberries and jelly round the seeds. They were nice. We ate them raw.

Mr Piesse had a vineyard at the side of the winery and he used to pay the Noongars to pick fruit for him. There was a horse which pulled a dray with boxes on it. People had to put the grapes in the boxes, black in one, white in another. The lady's finger grapes were the best. There were also almonds, pears and peaches growing up to the side of the old hospital. When we were kids, he'd tell us to help ourselves. 'Take a bag and help yourselves,' he'd say, 'but don't strip the trees and break the branches down. If I see any trees broken, no more fruit.'

There were two sorts of almonds, some sweet and some bitter. We soon learned which were which. The peaches were lovely—great big juicy ones. We used to eat and eat.

I remember Paul Beeck too. He had a saddle shop where the Commonwealth Bank is and a fruit and vegetable shop next door. He used to go in with his big leather apron on and say, 'I want some fruit for my grandchildren.' He was a nice old fella and used to spoil them all. They used to flock around him. All the Noongars' kids he used to call them his grandchildren. His wife would go out the back and cut bunches of grapes.

He'd make them all sit on the verandah and share them out. When he died all the kids were very sad.

Another sad time was when Mrs Eli Quartermaine died. She was his first wife and she'd been Cradle Hall before she married. That was her name—Cradle. I was living in a tent out the back of the farm and I helped Vera Diamond. She cooked for the family. One day she told me to pick mulberries for a pie. As I picked, I heard Mrs Quartermaine shouting. I wondered why she was shouting 'cause Vera told me to pick them. I went to see and she said to get Mr Quartermaine. He was down by the dam at the front gate. He came up. That was the last time that I saw Mrs Quartermaine. They got her to hospital but she died. I cried a lot as she was a lovely lady. She used to make me clothes. I was about ten or twelve at the time. I was staying with Vera so I could go to school.

The hospital was in Amherst Street then. I went to hospital once, when I had measles. Dr Pope was there then. I didn't like it. There was a passage right through with little rooms, doors all along. They put me in a little room and shut the door. They said I had to stay, as I'd give all the kids the measles. I was very sick, it was like a fire on me. They sponged me with water in a basin. No toys and nothing to do. It was a tiny little room, just big enough for the bed. I cried for my dad.

We weren't sad on Show Day though. We had lovely shows. We all used to go. We had fairy

floss, lollies, showbags with licorice and peppermint walking-sticks. About 1928, we saw a man eating razorblades. He put them in his mouth and swallowed them. After that he put a cotton in his mouth and pulled them out again threaded on the cotton! Once, Gypsies with caravans came to the show. They told fortunes with a big ball on the table. I never went in but some did. I peeped through the door. They wore big blouses and skirts. They had silky scarves on their heads, very pretty scarves they were. They had pretty bright clothes and big gold earrings.

Another thing we had was the circus. Worth Brothers used to come—'The Greatest Show on Earth'. They had it at the back of Roger's shop where the Supa Valu carpark is. There was a pound there for stray horses, and all open ground next to it. People used to pull up in the shade with their horses and carts. That's where the circus was. I used to go, never miss. I think it used to cost five shillings, but kids used to get under the tent. There were more that never paid than ones who paid. But they didn't seem to mind. They'd let them stay there. The circus had trapeze, balancing acts, clowns, camels, lions going through fire and elephants. Just like they have now, you know.

We had to get a permit from the police to allow us to go to the circus. No one was allowed in the tent after six o'clock—Noongars, I mean. We weren't allowed in town after dark.

We had happy times when I was a kid—always out in the fresh air and plenty to do. It

was a happy time, but then my mum died. I was nearly fifteen. She died very sudden but she'd got something wrong with her, I think. It was a Sunday and there was a big mob there. But they'd all walked over to a farm and I stopped home with Mum. Dad was away working. I heard Mum call out, and when I went over she was on the ground. I sat her up and she said, 'Look after baby.'

I tried to revive her but she was dead. I ran to phone down at the shop and asked the lady, Mrs Woods, to ring the police. She fainted, so I phoned and told them. I knew how to use it because I used to help in the shop. They didn't come straight away. They said, 'We'll be out tonight.'

I told them she was dead and no one was with us kids. They still never came till night-time. I phoned Dad as he was shearing at Leppards. He never came till night-time either. He'd been kicked by a sheep, so he had been to the hospital to get stitched up. I had to make a bottle for the baby and put her on Luke's bed. Then I put the baby on the other bed and I got Mum on Luke's bed. I washed her face and put a sheet over her. I took Luke to get water to stop him crying, and when I came back Mum was lying on her side facing the baby. I don't know how that happened, but she was cold.

At night they came with a big red truck, with a mattress on to get her body. Funny to do that. It was a red truck. Next day Dad took all the kids down to the morgue to see her. They didn't know

what was the matter. I tried to tell them she was dead but they didn't understand.

She had long black hair and they combed it down for her. She was only a young woman. She would still be living but she wouldn't go to the doctor. She wouldn't have her body cut.

There was a Church of England service and Mr Squires was the undertaker. She was buried at Katanning cemetery, and all the kids went to the funeral with Dad. She died on 10th October 1933.

We stopped home with Dad for three months, then he sent us all up to Moore River. I looked after baby Gertrude for a week, then Granny Mourish had her for a while. A bit later on, Welfare sent her to Moore River to be with us. I had two birthdays there. We never had anything for birthdays then. There was a school on the settlement, and Miss Milne was the teacher while I was there. There was a camp of grown-ups, with Mr Neil as superintendent and Matron was his wife.

The kids used to get a lot of hidings from the staff. I never got any hidings, but some boys—and girls as well—got put over a bag of flour and whipped with a stockwhip. They had marks and couldn't sit down for weeks. There was a dormitory for the boys. The girls' dormitory was split in half, girls on one side and mothers with babies on the other. The children had to help keep the place clean and tidy. I used to look after Luke, who was two, and go to school. I used to go up to the hospital to feed baby Gertrude and take

her for walks, until she died. Children got sick sometimes and were left in the dormitories. Sister Beeck was the nurse there and if they got too sick, they'd go to hospital.

When relations were coming, they'd put the kids in trucks and say they were going fruit-picking or something. They wouldn't let them see their families. Trilby Anderson was fair like a white girl, her mother was a full-blood from way up north. She used to cry all the time for her mother, but when her mother came they wouldn't let her see her. Poor thing.

They had full-bloods there from up north. One old woman was Granny Nellie. My brother was fat, with fat legs. She kept rubbing her legs and pointing at him. She laughed and kept wanting to feel his fat legs. Mr Neil said, 'Keep away from her, she's got a big cundee stick. She'll hit you with it and eat you raw.' I didn't take him near her after that. Those people came down from the north because they had scabies. They were supposed to live in a separate camp with a fence all round. They used to dig under the fence and get out.

They'd get you round the neck with their leestrap, if they wanted you. They were bad men. One little baby got lost. They reckon that lot ate it. The mother cried for a whole week, day and night, but they never found it. Once, a full-blood child died and was buried, but they dug the child's body up again and all ran away.

When I was fifteen, I left school and they put me on sewing. When school broke up they asked who wanted to go to East Perth Girls' School. I wanted to go. They had a meeting, but they sent all the girls from way up north, but not me. I wanted to go. So back I went to sewing on buttons and mending boy's clothes.

After a few weeks, I told Matron I was sick of that job. They said, 'Work in the kitchen, just for the weekend.'

'Only for a weekend,' I said, 'or I'll run away.'

Then Matron said, 'Would you like to work in the sewing room? Working on the machines?' We had a big order to do for up north—Mt Margaret, I think.

Working at that job I put the needle through my finger twice. We made men's trousers, boy's clothes and women's dresses. It was hard work, and if you got the trousers wrong, you had to pull it all out again. We worked early morning until it was too dark to see. When that was finished they packed up five or six bales, like wool bales, and sent them up to Mt Margaret.

After that Sister Newman said, 'We're having confirmation classes.' So I went. We called her Sister like they do in church. We had a Bible study and we all got confirmed. We had white veils and dresses. There were ten girls and about fourteen boys. Next week we were all dressed in blue and marched from church, all round the mission with a flag. That was for the King. The old one, I think, but I don't remember why. Then we all went to lunch and after lunch we went for

drill. Khaki shorts; white blouses with red, white and blue trim; white sandshoes and socks; and sticks with streamers on. We marched and drilled. There were white people there from Perth.

Then I told Matron I didn't want to go back to sewing, so she said, 'Well, you can work for the staff if you like.' I had to polish and set tables, be a maid at the tables and do their washing. I liked that, and that's where I stayed until I left.

After I'd left and was back with my dad, Sister Newman wanted to take me to Melbourne and then to South Africa, telling the dark people I suppose, and she wanted to take me but Dad wouldn't sign the papers. He'd never let a person go anywhere. So I couldn't go. She was so good to the kids at Moore River. She'd take them for walks and do Bible study and scripture. When she was in South Africa she sent me two dresses. Really pretty they were, but I never wore them, they were too good. I just used to look at them. Real pretty dresses.

When I left the mission I went to Perth, then to Mokine Siding to help with housework and the shearing team. I did upstairs cleaning and waiting on men at the table, and all the washing up. I was there three months, then went on to Mrs Snooks at Northam. They had a poultry farm. Five hundred fowls. I did all the housework, helped with the washing and tested eggs at night, for ten shillings a week. I got two and sixpence pocket money, and seven and sixpence went to Native Affairs to put in the bank. Years after I

wrote away and asked for it, they sent me fifteen pounds.

The Snooks were good people. I used to go out with them and their daughters to dances. They were teenage girls, one in school and two older. They were lazy. I was with the Snooks for two birthdays, sixteen and seventeen. After my seventeenth birthday, I rang Mr Neville, Native Affairs in Perth, to see if he could find me a place to board so I could go nursing. I had a friend in Northam who was a nurse, Annie Wheeler. She kept on saying, 'Why don't you come and be a nurse?' but Mr Neville wouldn't help me, so I couldn't. So then I wanted to join WAAF, but Dad wouldn't sign the papers.

Mr Snooks was in the 10th Light Horse and he used to come home on three months' leave. I used to saddle his horse up. Dapple grey it was, a big horse. I used to get him to let me ride it. The army horses didn't stop for gates—just went straight over. I hung on somehow. We nearly drowned once. It'd been raining and the river came down from Spencer Brook. It was flooding and the horse swam across. I nearly got swept away, but the horse managed to get across. It was Burlong swimming pool, at the top end.

Then I left in October and came home for the Katanning Show. Mr Phillip Crossley gave me a job at his Cliffden farm, so I went back and packed my things. 'I'm leaving,' I said.

'You can't go, you've got to have permission from the Welfare!'

But I was off. Once I was home, I worked for

Mr Crossley and I didn't care. Glad to get away from those chickens.

I did housework for the Crossleys. They had two children, Michael and Jill, and I stayed there eighteen months. After that, I went back to my dad who was working for Mr Shackley, Mr Frank Shackley's father. My dad had a job clearing and it was a big job, so I helped him. All the rest of the kids were there. While they were working there, William got hurt. They were burning a big red gum tree and it fell. One big limb fell on William and broke his hip. It pinned him down. He was in hospital nearly eighteen months. That was when he was about eleven.

When we finished there, Dad got a job with Clarry Garstone at Woodanilling, and we did a lot of clearing there. I went and helped Mrs Garstone in the house, living in. They used to go away a lot, playing golf and that. I used to look after the kids.

My first girl, Joyce, was born after I left Garstones. Her father, Phil Quartermaine, was in the army. He came home on leave but he went to Broomehill and had a big celebration. He was supposed to come back by Wagin to see his father and mother but they found him dead in the railway carriage. I was nineteen then, so I reared Joyce by myself. I used to put her in the pram and work around town. I worked out at 6WB, polishing all the floor in the transmitter hall.

That took me all morning—no electric polishers in those days. After lunch I did the washing, and finished about three.

The boss used to come at eight in the morning, to the place where we were living. We all had tents near the cemetery. He used to put the fold-up pram in the car. David came with me to mind Joyce if she cried, but she never used to, so he played marbles with their little boy. Then the boss would take us home again.

After a while I made up my mind to go to Melbourne. I was going to take my baby with me but Dad wouldn't let me go. So I stayed here and kept on working.

When I was twenty-one I married Billy Colbung. That was at the Registry Office in Katanning. Dad, the sergeant and a policeman were there as witnesses. I wore a blue dress and a blue hat—pale blue. And I had a bunch of Easter lilies. We had some photos taken outside the police station but they all got burned years later, when there was a fire where I was. Billy was a shearer for Paul Beeck out by the Marracoonda way. He was older than me, might have been in his thirties. I had two Colbung children, Brian and Michael. That didn't last long though because Billy was killed. He was out working in the bush. Someone beat him up and he died. They didn't find out who did it. That was before Michael was born.

After that, I went back to live in the camp next to the cemetery. We were given weekly rations and we used to earn money trapping

rabbits. We used to trap a lot. We'd get forty to fifty pairs a night. Mr Bell gave us the traps, and we got about five shillings and sixpence a pair. I used to take the fat ones home to eat. Dad used to say, 'You could get money for those.'

'Yes, but we've got to eat,' I'd tell him, 'and these are good meat.'

Up where the winery is, there was a freezing plant. They'd buy the whole rabbit, not just the skins. They'd load up and take them away somewhere. I think they put the rabbits in the cellar of the winery till the truck came. I used to sit in the buggy minding the children, so I didn't see. They had a big truck with flywire all around it. After they finished, Dad said, 'Don't sell the meat, trap for skins.' We got more for the skins than for the whole rabbit. It used to pay for tucker, trapping rabbits.

When Joyce was about four and Brian was two, I went out to Carrolup. The Welfare decided most of the kids that didn't go to school should go, so they had to go out to Carrolup. They bought a truck, a big one, and blacktrackers. All the kids were pleased to go, and the little ones jumped in too. They didn't ought to go, but they were happy because there was plenty of good food up there. Only a small amount of rations in town. I didn't have to go but I went with my children.

Sister Williams was out there at Carrolup, and Mr Williams was storekeeper and boss of the boys. They had brick dormitories for the boys, and girls were separate. I was put on washing. I

used to do the boys' washing. Two girls were in the kitchen. Two single men made the bread. They cooked all the meals at the kitchen, and we went up with billycans for the food, mostly stews. There was plenty of meat, milk and eggs, and all the kids got fatter. They had a school there. Mrs Mansfield was the teacher. She was an elderly sort of woman, but she learned them a lot. She was a nice lady and she liked the kids too.

Carrolup was alright then. It got worse later on. I had Michael while I was there. They had a hospital and Sister Williams looked after me. The first two were born in the district hospital. Joycie was born in the ward, but they had a little wing off the verandah where most of the Noongar women had their babies. Sometimes they were in the ward with the white women. When Joyce was born, there was a tiny little lady there from Tambellup. My baby looked small but she was seven pounds. Her baby was big, like a six-month-old. I couldn't stop looking at him. She was a tiny little thing. When her kids came to see her they were all big and fat. Such a big baby, he would hardly fit in the cot!

I remember when Brian was cutting his eye teeth he got gastroenteritis. He was in the district hosptial and Dr Caldwell said he would die. He just lay there with his mouth open. I said, 'I'm not leaving him here to die. I'm taking him home to look after. He might get better then.'

Dr Caldwell said I couldn't do that, but I wrapped him in the rug and said I was going. 'He'll be dead tomorrow,' said the doctor. They told me to bring the rug back as it belonged to the hospital.

'I don't need your rug, he's got his own white one at home,' I told them. So we went back to Carrolup.

Teacher Mansfield said, 'I know what will cure him. Give him to me.' She put one drop of iodine in some milk.

'Don't poison him,' I said.

'No, it won't poison him, it'll put a lining on his stomach and kill all the germs.'

He only had that one drop, and after that he could take his food alright. He got better after that. I made him a little soldier suit out of men's trousers. Long trousers and a little jacket. He had brown boots as well. The doctor used to come out every month. When he saw me he said, 'Well, Mrs Colbung, how is that little boy of yours?' I pushed Brian round the desk to show him. He picked him up and laughed. He wrapped his arms round him and hugged him tight. He would have been dead if I'd left him in the hospital.

Joan Jones, Lizzie Khan and me, we used to work in the hospital at Carrolup. After Michael was born I worked up at the big house for Mr Leeming. They had one little girl, Margaret. I used to get tinned stuff from town for Michael. He got real fat.

Then they gave me a job looking after the three grannies—Granny Cornwall, Granny Kelly

and Granny Quorup. They were worse than little babies. It used to make me feel sick, so I couldn't eat my dinner. I asked for another job.

After I left, Carrolup got worse. They used to flog the kids with whips. They'd wet the whip in the river and flog them with a wet whip. One girl had the marks all her life. It cut all her skin, but it was good when I was there.

Friday and Saturday night was concerts. We had happy times. We never worried about drink. Noongar people used to come for miles in horses and carts, and leave on Sunday afternoon. The Noongars owned horses and carts and sulkies. They tethered the horses in the paddocks. Now it's all drinking and fighting. At the concerts, one man was the MC. He'd call out to different ones to come and sing. One man and woman, Noongars, they used to do the sword dance—you know, the highland fling.

Someone used to play the piano accordion. Ray Williams, he was musical, he used to play for the dances. There was a guitar and mouth-organs. Young Jackie Coyne had a guitar.

My brother, William Morrison, played the mouthorgan. We used to have the dances regular. They used to have their tea and shower and get dressed up. No short dresses, all long ones. They looked nice too. There was no church out there though. After we came back and lived on the reserve, Mr Keith Wells started up a church on the reserve. That was good. My dad was always the first one there. He used to round up all the kids and we'd all go.

People were musical at Moore River too. I remember one old man, he had a long beard. He never had any schooling, but he made a violin and used to play it. White folk used to come from Perth to hear the music. Didn't think Noongars had it in them, I suppose.

When Michael was about eighteen months, I married Nichol Hart. We were married in the Church of England church in Katanning. He earned money trapping rabbits and working where he could. We had Enid, Janice, Leonard, Neville (who died at eighteen months from gastroenteritis), Clive, and Ian, who was stillborn. We were living on the reserve when Neville got sick. I took him up to Perth to the hospital. He died there. I took him on the train—the Albany Progress. It went at night and you got there at eight in the morning. I took the tram from the station to the children's hospital, but he died. He was buried at Karrakatta cemetery.

I went to the funeral, but by the time I got there it was too late. A friend had promised to pick me up from where I was staying but she never turned up, so I was late. They had a lot of other people to bury and they were just leaving the graveside when I got there. There was an undertaker, and Dad was there with my stepmother, Dorothy. She married Dad. She's still alive, you know, living in Manning. I was very upset when Neville died.

Then Nichol went off and I reared up my children by myself. I couldn't get any rations, I don't know why. They wouldn't give me anything so I had to work. I worked Monday to Friday at Central Bakery. That's where the Bakehouse Jeanery is now, in Clive Street. They used to give me bread, sugar, tea, dripping and seven pounds a week. On Saturdays I cleaned house for Dr Pope's wife. That was thirty shillings more. We lived on the reserve then.

Peter Johns, Russell's father, had a humpy, and when he went off shearing he let me and the kids live in it. You don't see humpies round here anymore. They were better than a tent. There's just one room, and it's made by driving four timbers in the ground for the corners. The walls are galvanised tin and a tin roof. There's a timber doorway and the fireplace is tin, with a tin chimney. Inside it's lined with hessian bags. You get potato or wheat bags, split them longways and sew them together with a bag needle. Inside was a double bed, a single bed and a little table to eat off.

The humpy was on the other side of the creek from the reserve. I used to walk over to the reserve to do my washing sometimes, as they had a laundry block, or else I'd do the washing in the corner of the saleyards. There was a tap there by the cattle trough. I made two buckets out of kerosene tins with wire for handles. I used to make a fire in the corner of the saleyards and boil up the clothes. I always took my stuff back home to dry though. No good hanging it up on the

reserve—people would pinch it. They used to pinch stuff off your line, specially my girls' clothes.

When they put up the kindergarten hall on the reserve, I slept there with my kids. In the morning, I'd clean up and pack everything in the little room at the end of the hall. I wasn't there all day, I was out working. The children were at school.

Then my uncle, Phillip Morrison, came from Wooraloo Sanitarium and brought me a tent, and I got some beds. Someone built a kitchen on the front out of hessian bags and I lived there about six months. My sister Edie came and stopped with me. My brother Arthur made me a big box with a padlock on it. I kept my food in there. People used to come around from the camps begging food. I wouldn't give my food to no one. My kids had to eat, same as everyone else.

While I was on the reserve, the Welfare took Joyce, Brian, Michael and Enid, and put them in Rowlands Mission. That was good. They wouldn't go to school. I used to have to drive them there every day with a good big jam-stick. They used to go off and fight with the other kids.

I used to stay with Granny Spitty, Jack Spitty's mother, a lot when I had the Hart mob. I'd have a room at her place and do work for her when she was sick. The children stayed there with me. Mrs Bonnie Kowald used to come and have Sunday School. Aunty Bonnie, the kids called her. Dad had gone away to Perth with Dorothy, his second wife.

After the older kids went to Rowlands, I went off with Ted Ford to Jerramungup. We were there nearly two years and I had Janice, Leonard and Clive with me. Before Rhonda was born, I came back to Katanning and stayed at Mrs Spitty's, waiting to go to hospital. My sister, Jane Maher, had the other three. Once Rhonda was born, we went back to Jerramungup for six months, and then I sent the other three to Rowlands. I rang Wright Webster, the welfare officer, and he came and took Janice in his car. I took the other two myself a bit later.

We didn't stop at Jerramungup long. We came back to Katanning. After Rhonda, I had Susan and Eddie and then Brett—he died a new baby, then Mary, then John Thomas, but he died as a little baby, although he was eight pounds when he was born. He had sugar and they couldn't do anything for it then. That was fifteen altogether. Two of the Harts died and two of the Fords. All my babies were born in Katanning hospital, except Michael. Some in the wing and some in the ward.

We lived in the shed in Mrs Spitty's garden those years. We left our things in the shed and went out working, Nyabing and round the place. We'd take what we needed for the week, but always came back at the weekend. Mrs Spitty was good. She'd come and see if I needed money for food. She was like a mother to us. I used to make stew for her and look after her. I'd make tea for her in the morning and light her fire. At night I'd put her to bed and see she was alright for the

night, before I went out to the shed.

Then Ted Ford went off up to Kalgoorlie or somewhere. I lived at Neville Quartermaine's farm for a long time after that.

It was best in those days. Kids these days always seem to be getting sick. They get one thing and then it goes round and they get sick again. We never got sick. Out in the fresh air all the time, I suppose. There was plenty of work and food was cheap. You could buy a big load of food for a little bit of money.

Years ago, old people were happy, not like today. They never worried about the drink. They'd work around farms and were happy. Now they spend their pension on drink. I'd rather live then than now.

TAZUKO KAINO
A Very Special Family

TAZUKO KAINO

A Very Special Family

Everyone in my story and who knows me in Broome, I have to thank, respect and love, they are the people who helped me.

My granny, Polly Vincent (her second marriage surname was Pedro), is Mum's mother. Granny Polly's mother, my great-grandmother, was a full-blood Djugun woman. Granny Polly was born in one of the houses on the bend at the edge of Dampier Creek in Broome, close to the pearling-boat building shed. We knew it as the 'carpenter shop' in Chinatown, off Grey Street and Dampier Terrace.

The police used to take the half-caste children away from their full-blood mothers and place them in an orphanage, to be brought up in the white-man system. They were told not to remember their mothers and families. Broome had treasure in our ocean, so the pearlers came and used our men and women to dive for the pearls, many died while doing that. There were forty-eight different nationalities in Broome in those days. That is why the Djugun people have

lost their identity and culture.

Granny Polly was born very fair, she could have passed as a white lady, but she was never taught to read or write. Her father was an Englishman. The people that stayed close by would run across to tell my great-granny that the troopers were coming. They could hear the horses' hooves galloping towards the bend. They would spread black charcoal dust over Granny Polly's face and body, then hide her in the mangroves and tell her not to make a noise or she would be taken away from everyone. I'm glad Granny wasn't found.

My Granny Polly had four sisters— Philomena, Celicia, Lydia and Dot. Granny Polly had six children. Mum's name is Mabel Mary Slater (Vincent), born 7 February 1914. Mum and Uncle Stan was sent away in the 1940s, and Mum worked as a housegirl in her younger years. Mum returned home after World War II, she couldn't forget Broome and the memories.

Mum took me to corroborees, cockling, collecting oysters, etc., to teach me how to live off the land and look after it. When I was five to nine years old, Mum boiled bloodwood bark for me to have a bath and drink a small amount. This, Mum told me, will keep me healthy and I won't get infected sores on any part of my body. The drink will help me from catching viruses such as colds and so on. I feel that the bloodwood bark did me some good. My ex-husband Richard Garstone gets cold sores on his lips, I'm clear

from any cold sores, and we were together for twenty-seven years.

When I was young Mum took me to corroborees outside of One Mile Reserve, that was when Butcher Joe told me this was a Djugun dance and this is your land—Djugun land— and that Mum was a very powerful woman. Mum told me that we were Djugun and that this is Djugun land, at a young age. When Mum was young, a Lawman took her in the bush and put a 'nail' in her head. 'This will make her mind strong and to help her people.' She said that as I'm her only child she has passed her strength to me. I suppose the feeling and dreams that I had, to start Djugun Aboriginal Corporation, was my ancestors waking me up to help the Djugun people. I'm proud to say that I'm Aboriginal, of the Djugun race. I would like the Djugun people to be recognised and not forgotten. We had a hard life in the 1800s and 1900s with the luggers etc. Now it's our time to be recognised and live in our little town in peace.

The land and customs is always in our hearts and minds, we cannot forget what our mothers have taught us about how to live and respect our land. And my generation will keep on teaching and passing on what we know to our children. I have four children and one grandson, Luke. My daughter Marcia lives in Looma Aboriginal Community with her husband Mathew Pindan. When Luke stays we both go and eat oysters off the rocks daily. The foreshore has lots to eat that

can keep you alive, if necessary. Some shellfish, after cooking, you may want to close your eyes while eating, the colour isn't very appetising. But we enjoy them. My children use them for bait. My children are doing their own thing, but I still go to Crab Creek to pick up cockles, oysters and to fish, that is my time to enjoy our land and the fresh food. The open fire is the only way to cook sea and bush food.

Back in the old days, there were no books to read about our ancestors and their stories, so it was all told verbally. That was how we remembered all of the stories from our mothers and fathers.

Etsuzo Kaino is my father. I can only remember what Mum told me. I don't really know how long he lived in Broome before I was born but I know that he had to go back to Japan when I was two years old, his visa-contract ran out. My father worked as a pearl diver for the pearling companies Placanica and McDaniels.

Mum told me that during World War II none of the Japanese were trusted by the Australians, just in case they got to a radio to notify the enemy. So they were put into the local gaol at night, but during the day they were allowed to go to work. Mum said that once, when I was six or eight months old, we all went to Cossack for half a year.

When I was born, Father was a very proud man to have a baby daughter. He asked Mum if I could bear his name. Mum agreed, so she picked an Australian name, Vivienne, and Dad's: Tazuko Kaino. I grew up with the local Japanese and they couldn't say Vivienne, so I was called Tazuko. Mum's friends couldn't say Tazuko so they called me Vivienne, or something like Tazuko. I still am called Tessica or Taccia. I'd answer to anything that sounded similar. I am very proud of my Japanese name.

Father must have known that he wouldn't be around for me, so that is why he brought me material things, and photos to remember him by. I have kept all that he has given, from old china bowls to his painted baler shell. Father was very clever with his hands, he could sew, crochet, knit and paint. Mum said that he crocheted a beautiful set for me, because I looked so white and so transparent that I needed to be kept warm, to build my body up. Mum must have given the set away, but luckily she kept one baby shoe.

I never knew my father, but I cherish the photos and can see Father in my eldest son David. So can a few of Father's workmates that are still in Broome.

I feel that I didn't miss out because I lost my father at a very young age—I was two. And a wonderful new father figure came into my life.

Shoji Takata, my stepfather, I loved as a father. All my memories of him are fond. After he went back to Japan, when I was thirty-nine, I had this guilt feeling about my past. On how I behaved when I was in my mid-teens. I respected Dad in every way—he was the best father figure in the world but I let him down in a big way. I didn't get on with Mum, so deep down I wished Dad was home a lot longer. He would spend five to six weeks out at sea, and five to seven days home. While he was home, we enjoyed our time together. I remember whenever he was going out pearling, I never said goodbye, only 'See you when you come home.'

During the lay-up season, which started approximately 20th of December each year, the luggers were maintained and added to with the latest equipment. They started diving again on the first neaps in March. The Japanese, when arriving in Broome, made a three-year contract with the pearling masters. So every three years they were allowed to go home and visit their families, and the employer paid for their tickets. Some received returns and others, like my father Kaino, had a one-way. He never came back.

The season always began with the lugger picnic. They were the greatest. Everyone in Broome enjoyed themselves immensely, and the memories are fantastic. Every lugger had to use sails only. There were five pearling companies in the '50s. They all had their own starting line— Male & Co from Streeters Jetty, McDaniels from

the front of the Conti Hotel, Archer from the front of the Conti as well, Wally Scott from the front of Roebuck Hotel, Placanica from the front of the Roebuck as well—and finished at the old jetty, which was burnt down in the '60s. Now it is called Town Beach.

Yoshinori Maeda and Shoji Takata arrived in Broome on the same plane, and they had a contract with Wally Scott. My father Kaino was with Placanica when I was born.

I can remember going to the Streeters jetty to board on the lugger. Dad was with Male & Co, then the company changed their name to Pearls Pty Ltd. Dad's was always the winning lugger for us kids. We were all well looked after by the crew. If any of the passengers had too much to drink, that person would be taken down to the divers' cabin to rest, just in case there was an accident. The Japanese supplied all of the food, drinks and entertainment. They were the best, they made everyone feel welcome and warm, nothing was too much. Their hospitality was fantastic and when you were at their party, your glass was never half empty, they always wanted to keep everyone happy and satisfied. This makes me very proud to have a Japanese father. I still pour the other person's drinks and I enjoy doing it. I feel a bit embarrassed when someone pours mine. I feel I am blessed to know both Aboriginal and Japanese customs.

When we lived at the back of Streeter & Male's store, close to the marsh, we really enjoyed

ourselves. I would go and buy a brick of vanilla icecream, Fanta for Dad and Coke for me, so that we could have our spiders with Dad's favourite, Marella jubes. Some days, on dusk, we'd sit outside on the garden chair, but it all depended on the time of year. We would pick out shapes in the clouds, or see patterns in the stars. Dad told me something that I never forgot: 'Pink stars are the girls and blue stars are the boys.' I had to be a good girl to be entitled to be up there with the other girl stars. I hope that *my* children haven't forgotten.

I was a spoilt child, yet I didn't get everything that I wanted, I had to earn it. Whenever Dad had a bad back, he would ask me to walk on it. I was scared that I might hurt him with my weight. But he would tell me, 'You're so skinny, I can't feel you walking on me.' Dad was a thinly built man, but very strong. Every morning he would have one or two raw eggs, straight from the shell. He said that it gave him energy and that he needed the raw eggs because of his diving. Even today I have a raw egg with hot rice or soup. David, my eldest son, has the same. I don't know if I do this so that I don't lose my memory of Dad.

Once in a while, Dad would ask me if I would pull out the grey hairs in the front of his head for a penny. I never got the penny but I wish I never touched his grey hairs, because when I saw the last photos of Dad, back in 1993, that Jim and Chris Kable showed me, the only mass of grey hairs were in the front of his head.

Dad enjoyed his time with the other men when he came in from the sea. Well, this time they went to the gambling house, next door to where the Roebuck Bay Hotel is now located. The house was actually built where the Pearlers Bar now stands. What is now the Pearlers Alfresco Dining was then a shed to store diving gear for Costello Pearling. Once the whole of Dad's wages was lost and he owed the bankers as well. So we lived very lean, frying steak, not fillet, crayfish, vegies from the Japanese camp and rice, of course. The best thing was the rice balls; the Parriman family enjoyed them as much as myself. Dad knew that we all loved them, so he would make dozens. Mum and Dad had no cigarettes, very little beer that week. Dad was very ashamed that he lost all his money gambling, so he gave up smoking. But what fascinates me was that if Dad wanted to give up smoking he could, without too much trouble. I wish Dad had never touched the cigarettes.

I kept chickens, to feed the family and the camp, but no one was allowed to kill my 'Aunty Ruby'. She was black and beautiful. She didn't give us many eggs, but she was mine, and seeing that I fed the chickens, Dad said it was OK.

Dad was the head diver and all the Japanese and Indonesians would go and talk to him, with their troubles or friendship. I felt that I had a very lonely life, I was someone who you just made your respects to, and not to have as a friend. Just in case Dad found out, he was very protective of me.

The Japanese divers liked to go fishing or collect cockles to have with their drinks. Tanaka was the only one with a car. He would take us out to Crab Creek, where we would climb down the red cliffs to get to the cockles that were in the sand, not in the mud.

The only place we used to go fishing was at Prices Point, where we fished on the incoming tide, off the reef. Once we nearly got caught by the tide. The race was on, for young and old! Dad would always keep an eye on me at such moments, plus growl if I was taking my time. You see, the tide didn't slow down for anyone.

All of the houses were just corrugated tin that ran horizontal, making the building look longer than it really was. The floors were all wood, even the bathroom. We had no under the floor plumbing, drain holes or sewerage tanks, all our waste water from the bathroom would escape through the floorboards. Washing up was done in a round tub, so that we could throw the slops on the gardens or lawns.

Once a week Mr Jack McKenna would come and change our toilet bins. One day, a member of the family told Mr McKenna that their brother was in there. Mr McKenna was a great bloke, full of laughs, and he told everyone not to say anything—he was going to try and make it feel as if a snake was in the bin.

Well, he moved as quickly as possible to change the bins, only one thing went wrong. While trying to move the bin, he made a noise,

you should have heard the scream from the toilet. Our toilet paper was cut-up newspaper. Dad would rub it together to soften it for me, which I didn't know until many years later.

Once we all planned to go to Prices Point for fishing. Well, that night a cyclone came, and was she a beauty! There was only one bedroom situated in the centre of our house, so the three of us were in bed and we could see the roof was lifting. Dad went next door to Morgan's house, to borrow some rope to tie down our roof. He climbed up to the eaves and tied it on, then to the bottom frame that was near the floor. You see, our house wasn't lined, just wooden frames and tin. It was still cool in the summers on the verandahs, but the bedroom was warm during winters. The next day the town was a mess, Chinatown power lines were down, mainly outside Mr Jack Knox's butcher shop (where Paspaley Pearls' shop and office now stands), which was our main line as well.

All of the buildings in town were very old, the original buildings of the old days. They had stood up to the beatings of other cyclones. The butcher's shop side wall caved in on the marsh side facing west. The divers' camp had steps to the sleeping area on the outside of the building—well, the steps were so badly torn, they had to be removed. Whoever slept on the first floor had to get their clothes down from their clothes racks. Well, they had to climb, swing and act like monkeys. Granny Pat's, the house of Aunty Mena

Dixon's mother, was a one-room house made of tin, with a piece of hessian bag for a door. I loved visiting there, it was so homely, plus she made the best bread and tea I ever tasted. The cyclone flattened Granny's house.

Dad wouldn't let me go with the other children, just in case we got too close to the power lines. So Dad and I went for a walk. The Sun Pictures wall, adjacent to Wing's Store (now Shekki Shed), was down; the whole right side fence, that separated Uncle Barber's and Aunty Gwen's houses, was flattened.

All the children called everyone Aunty and Uncle out of respect, and we all got on well together. There was no friction amongst us, we were all equal. I was the only Japanese-descended child in Chinatown. Many were of Malay, Islander, Aboriginal and Chinese descent. The full-blood Aboriginals were lovely people. Once I heard Dad telling an elderly full-blood man, if he or his family saw me anywhere I shouldn't be, just tell me to go home. All the adults looked after the children, even if the children didn't know them. We still had to do as we were told, or else.

Dickie Morgan owned and ran a pearl farm of his own. Dad didn't like him because he was one of the opposition to Males Pty Ltd, but he was our neighbour. The house was normally rented

out, most of the time. His house is still standing today, opposite the new Post Office.

When the main highway into town was being built, some of Mum's relations came down from Darwin, and they were staying at Mr Alfie Martin's house, which we could see over the marsh. Jeffrey Parriman and I took the twins back across the marsh. When we dropped them off, we walked into every puddle we could. There were two large holes on the side of the highway. The water was to our knees deep. Not taking any notice of where we were walking, I cut under my left big toe, and it was nasty. Jeffrey helped me home. Dad got the kero to try to stop it from bleeding, but it didn't work, so he told Mum to go next door and ask Michelle if he could drive me to the hospital. Michelle was renting Dickie Morgan's house. He took me to the hospital, and Aunty Elsa Foy, nee Roe, was the sister who put eight stitches in my toe. Her mother and father was one of the neighbours. The Roe family, Parriman family, Morgan's house and ours were in one little cluster. Dad got on well with Uncle Jack Parriman (I called him Uncle Pie), who helped Kevin Buckeridge to build the luggers. There's a clearing that allowed the fleet to sail up to be serviced during lay-up season.

Whenever it was spring tides, the water would just lap through the floorboards. All the children would come home for lunch on those special days. We knew the high ground to walk on to get home, but after lunch the tide got higher

and we used to get wet, so we had to stay home. Well, we did go to school in the morning, and it only happened about four or six days a year.

When we had our monsoon rain, I saw Mum and Dad having a bath fully dressed. I thought it was very unusual. Dad always liked my hair long, so he kept a rinsing tub full of rainwater so that Mum could wash my hair. Mum would put lemon skin and leaves in it to make my hair smell nice. I have tried it on my girls' hair, but I can't get the smell right.

I wasn't married when I had my first child, Marcia Yvonne Kaino, she was the apple of Dad's eyes. Dad and the other Japanese boys just spoilt her.

I remember the first day I saw Richard Garstone. Glenise Hackett and I were working as housecleaners at the Continental Hotel. We were in one of the units, and we saw him walking towards us. I thought then he was alright—a man who knows what he wants, and he'll get it.

Marcia and I were in a car accident in late 1972, and by luck, you can say, John, Richard's twin brother, was visiting his younger brother, Kevin. John saw the accident and came over to help. Marcia was thrown out of the front of the car onto the road, receiving a cut on the head, but nothing else, thank God. I was under the dash, so John had to stop me from swallowing my tongue. We were alright. Richard and John was in the panel beating business. It took me three

weeks to go and look at the damage on my car, that is where Richard and I saw eye to eye.

While Marcia and I were in hospital, Dad was very upset that one of the nurses asked him to leave Marcia's bedside because he wasn't a relation. Dad soon told her where to go. His words I can still remember: 'This my granchil', you can't tell me what I can do.'

Richard and I lived together for three and a half years before we got married. Our first son, David Shoji, was born out of wedlock. We named him Shoji after Dad. I know that Dad was just my stepfather, but David reminds me of him, so patient, placid and quiet, it must be in the name. Richard and I got married when David was over a year old. We had two more children, a son Eric Richard and a daughter Kandese Misae. All of my children love to pick bush fruits that are in season, they recognise the leaves and flowers. We can go into the bush and we know which tree, bush or vine we can eat for medicinal reasons and which not to touch. If you want to wash yourself, there is a soap tree.

Dad brought his wife, Ryoko, to Australia, and she didn't like me, but that didn't stop me from seeing him. I use to go and talk to him while he was mending the pearl nets, in the old shed over the road from the Continental Hotel, facing Dampier Creek. It used to be Dyson's Store, my Uncle Fabian Brellante used to work there in the 1940s. Ryoko had a stroke in early 1982. It was awful. And I didn't want to upset her in any way.

When Ryoko returned home, a few of the Japanese men called around to welcome her home.

I had a benign tumour removed from the centre of my brain in October '82. The second operation took five or six hours to remove the whole tumour. I was in a coma for four days. Richard, my husband at the time, was there supporting me for the whole four days. I felt guilty at the time that I didn't wake up with my husband touching and talking to me. My bed was near the main door of the intensive care unit, when Dad and Kaino (no relation to me) came to visit. Dad came in but the Sister asked Kaino to wait outside. Richard thought that he'd have a break for five minutes while Dad was there with me, so he asked Kaino to go in and pull the screen around so that the Sister couldn't see. I remember Dad calling me: 'Tazuko, why are you still sleeping?' I replied, 'Hello Dad, what are you doing here?' That was all I remember. I was fine after he left. Two days later I was back in the wards. Richard had to leave because we had four young children, with Kandese only two years old. And we had a business to run. He was away for three weeks.

I hated our last visit, when Dad was going back to live in Japan. The family and I thought that a great present for him would be towels, the colour that he likes. So that whenever he had a bath he would always think of us. We both didn't know what to say or do. The children broke the

silence, and I was glad because I couldn't say anything, my throat was sore. I was never allowed to show my feeling in public. Now I wish I had. But I did give Dad a big hug and kissed him on the cheeks, and most of all told him I loved him and would miss him. All this was in his ears only.

Dad passed away in May 1993, and a year later I received one of his shirts, towels and a photo. I can't explain the feeling I had, but when I arrived back at the office I had to take the shirt out, and I did a very foolish thing. I put it straight to my nose, hoping to smell him. The smell that he had when he arrived home from the luggers, or his own smell. Boy, do I miss him.

I remember how Richard wanted to leave Broome and have his own little motel, run by the family. I didn't want to leave because Mum was still here, and she didn't want to leave Broome. Mum passed away in March 1985, well there was nothing keeping us here, so we left Broome in December 1985. Mum knew that she was going to leave us, so she told me to buy whatever her grandchildren wanted. I was angry, but Mum put her foot down. Mum left us three months later. Memories of Mum always makes me smile.

I can say that my memories will never leave me, they will always be in my heart and thoughts. We can't keep the person that we love for ever on this earth, only in our hearts.

MAGDALENE VAN PREHN

Young at Heart

I was born Maggie Ybasco in Broome on the 22nd of June 1927, the sixth child in a family of twelve. I was brought up a strict Catholic by the nuns and this was the foundation of my survival in the years ahead. At that stage of my life, I could never have suspected how vital my faith in God would be throughout my life.

My childhood days were happy and carefree living in Broome. There has always been an ethnic community in Broome and all of us kids learnt to speak the Pasar Malayan language playfully.

My father came to Australia as a pearl diver when he was a young man. I don't know any more about him as people never used to say anything in those days. My mother was born in Broome of Japanese-Filipino descent. She was raised in Beagle Bay by the nuns because she was an orphan. They used to call her Japanese Theresa, that's all I know about her.

Broome was such a beautiful, peaceful place to live in and all our schoolmates were a mixture

of Filipino, Chinese, Japanese, and Asians from all parts of the countries around Australia. We all played together as a happy, united group of ethnics and Aborigines and there was no hatred in those days. I wish I could say the same today. We lived in the house in Napier Terrace, which is now Sheba Lane Garden Restaurant.

I must have been around five when my father took us for a holiday to his home in the Philippines, the province called Camarinis Norte. All of us kids decided to go for a swim in the river. I had no idea how dangerous it was. Before I knew it, I was desperately trying to keep my head above water. I almost lost concentration and swallowed so much water that I was going under altogether. All of a sudden, I felt someone pull me out by my hair and I was choking. For a long time after that I didn't go swimming, but luckily time heals all wounds. Later in my life, I came to love the sea, and swimming is one of my most enjoyable hobbies.

As kids, we loved nothing better than to run down to the beach to swim, fish and make damper the primitive way. If we caught fish, we made a fire and roasted it on the spot. It always tasted so good and I still think that is the best way to eat fish. If by chance someone gave us a piece of turtle meat, it was a delicacy to roast the meat on a fire the same way, and to top it off we sometimes used to make billy tea, which sure didn't taste the same as home-made tea.

Many a school day we would skip off and play down at the beach, but the strict Sister

Raymond would fetch us from the beach, and when we did get back to school we sure had to cop it. The nuns used to whip us, either with a long rod or a leather belt. On command, you would put out one hand, then another, and, boy, those slashes came down hard! We'd pretend to cry, and back in our benches we'd be laughing so she couldn't see us, or so we thought!

The highlight of our school days was the yearly picnic which the nuns used to arrange to some faraway beach, which was probably the now famous Cable Beach. We kids used to hang around the convent kitchen trying to get a glimpse of the goodies. The smell of all the lovely cakes made us hungry. On the day of the picnic, I used to bring along a small container to take some home for my younger brothers and sisters to share. We were all loaded onto a truck. It was a real thrill, as nobody had a car in those days and the one taxi belonged to Jimmy Chi.

I still have a wooden crucifix that was given to me by a very old nun called Sister Xavier. I was about ten at the time. Fifty years later, I still cherish that crucifix. It goes wherever I travel in the world.

I also recall the days of no pocket money, when we used to try to sneak into the town's picture show between the big people. We used to get up to all sorts of tricks, teasing the old Japanese people or pinching lollies from the grocery store down the road. If we had a penny, we'd spend it on sweets. If we had none, we'd run past the Chinaman's shop, stopping to pinch

a couple of sweets and run for our lives. If by chance the old Chinaman did catch us, he'd pinch you and practically break your arm, he was so mad at us. On the other hand, this same old man used to give my parents a lovely big basket of goodies every Christmas. So old Wong was a good man.

I used to love rounders and such ball games, and we'd use the old convent wall and its surroundings for our games. In my day, there were only two schools in Broome: the state school and the nuns' school, which were the terms used. I didn't know anything about the White Australia Policy that was around in those days. I always thought it funny though, why the white kids were in another school while we were in a school taught by nuns. I vividly remember two little white girls always playing together in their front yard, which was fenced in. When our mob used to stop and look at them, they would just look back, that's all. I realise now that it had to do with the White Australia Policy. I still sometimes wonder if there is still some of it around even today, with the news and commotion about racial tension around Australia.

Just before war came to Australia, the Japanese came to our waters around Broome with their fishing sampans and a big mother ship. The Japanese crew used to roam all round the Broome area, taking pictures everywhere. They asked us kids to gather all the steel nails and give them to them. We kids thought it was funny that they asked us for rusty nails and the like, but we were

paid a couple of pennies for each item. Naturally, we did our best to gather as many as we could.

A couple of years before World War II broke out, my parents moved to Darwin. We kids never knew why, but years later I realised that it was the Depression then and everyone, especially a big family like ours, had a hard time surviving. Poor old Pop must have had plenty of worries to try to feed us kids alone. He set up a barber shop in Darwin like the one he had in Broome. I didn't like Darwin at all and felt the loss of our friends and schoolmates in Broome.

Then the war came and, in a matter of days, all women and children were being evacuated from Darwin. I vividly remember how we were put on the last ship that had escaped from Java, full of refugees, mainly Dutch women with all their kids and their maids. We were halfway to Perth when they raided and bombed Darwin. Not long after that, Broome was attacked. There is a tombstone standing near the beach in memory of the fallen Dutch people who were gunned down in the flying boats on the shores of Broome.

One of our schoolmates, Dougie D'Antoine, became a hero by swimming to and from the flying boats to rescue many of the women and children who were terrified and screaming as the Japanese planes attacked. The blood from the injured should have attracted the sharks, so God must have watched and protected him during his dangerous mission. Dougie was honoured for his bravery and all the Broome school mob are proud to know him as a school

mate. Good on you, Dougie!

Soon after we arrived in Perth, some of us were placed in a Catholic orphanage. For breakfast each day we had cold cuts of mutton. Luckily it was only for a short period while our parents found a place to live. My dad set up his hairdressing salon in William Street with the living rooms upstairs. At the orphanage, I helped at the daycare centre with the toddlers and enjoyed doing something useful. There were strict rules and regulations in those places, which were hard to get used to, coming from Broome's carefree lifestyle. As I was exposed to so many different circumstances later in life, it was good to become flexible and adjust to changes in places quite easily.

We spent the rest of the war years in Perth. For the first time in our lives, we found what it was like living through winter months. We had to wear winter clothes and have a fire burning! Sometimes, air-raid sirens would go off in the middle of the night and we had to run to the nearest shelter. But there were very nice memories, especially as it meant that as teenagers we could go out and have some nice times with the new friends we made. The US navy had some Filipino sailors, who came to our place because old Pop was only too glad to meet some of his own countrymen. Of course, we girls liked the young blokes, who looked just great in their US navy uniforms. I still have some photos taken during the war years at the parties we went to. We loved every minute of it.

The only thing I regretted from those years was that my studies were interrupted, and my sister Annie and I were more or less forced to work in the factories to help support our parents and let the younger ones continue their schooling in Perth. We all had to make a go of it because in those days there were no dole cheques to see you through. The lessons we learned were a good grounding for the following years; experiencing things the hard way turned you into a battler and you were a better person for it.

By the end of the war I was an adult, and in 1946 I met my husband-to-be. He had been a prisoner-of-war in Japan and was sent to Perth with the other allies to recuperate. He was lucky to survive the horrors of the second atomic bomb at Nagasaki. We were married in 1946 and left Australia in 1947 to live in Indonesia, which was still the Dutch East Indies. Being a navy man, my husband was transferred every year. Indonesia was a war-torn place when two other Aussie brides and myself arrived in Batavia (Jakarta). I was only twenty. We were young and inexperienced, very much at a loss with our husbands of a Dutch-Indonesian background.

The first year, we all lived in Jakarta, keeping in close contact with one another because our main problem was the language barrier. I would really love to know what happened to the other two brides. Luckily, my upbringing in Broome helped with the language and I really got to love Indonesia because of the similar tropical lifestyle. When my first child was born in 1948—

a boy, Michael—my whole life changed dramatically. My parents-in-law were very kind to me although I did not speak the Dutch language at that time. We managed to get along quite well with the use of the Malay language. Even today I can understand it fairly well, although I can't converse in it fluently as I did as a child.

There were beggars everywhere. I was advised by my husband and in-laws to ignore them. I wished many a time that I could just give them a plate of food, because we had enough ourselves. I used to throw open our door first thing in the morning. My husband's breakfast would be the leftovers from the night before with a steaming mug of black coffee, called *kopi tubruk*. One morning, my husband called out, asking why his breakfast wasn't ready. I looked and there was nothing on the table. Some poor beggar could not resist the temptation and took the lot. In his haste he had spilt some of the food on the floor. I could not even get angry.

After a year in Jakarta we were transferred to Malang, which was in a mountain area and much cooler than Jakarta. It was a naval base and the only thing that separated us in our housing was a high fence. I was young and a mother, so I was busy trying to make the best of it. In the meantime, I also had to face the fact that the war was not over as far as the Dutch and Indonesian people were concerned. It was to stay that way for the three years I lived there.

The year that I lived in Malang was a

traumatic experience for a young bride and mother expecting her second child. It would turn to horror at night when my husband was called out on duty and I was left with my maid sleeping indoors with me. We had to lock and bolt the doors. We were both young and she was as terrified as I was. Practically every night there were shootings going on all around us. Of course, the navy barracks was a main target. I shudder to think back on it. I became a nervous wreck, and later, when my second child was born—a daughter, Geraldine—she was a sensitive baby and a sickly one at that. It left a scar that proved to be one reason for my big nervous breakdown some years later in Holland.

My husband was almost killed when ambushed on the way to Surabaya. They had to run from their trucks for cover and shoot it out with the Indonesians. He came home crying like a baby from the experience. I just went limp myself. The convoy before them had been slaughtered. My young neighbour gave birth to her second child just after her husband had been ambushed and killed in that terrible war. Her little toddler could not understand why his mum could not stop crying. I was devastated. I was too young and naive to understand the impact of the situation on me.

I was relieved when, after a year in Malang, I went to live in Surabaya, which was peaceful. Geraldine was born there. I was thrilled at being a mother again. After a year there, Indonesia gained its independence and we had to make a

choice between being a *wally nigara* or remaining a Dutch citizen and leaving Indonesia for good. My husband's career was in the Dutch navy, so we had no choice. We went to Holland, and it was the first time for him in a cold country that had only existed for him in history books.

We left Indonesia in September 1950, on a ship called the *Sibajak*. It was a journey that took one month in those days. Little did I know how often I would long for the tropics. We went through the Suez Canal but were not allowed to take pictures of it in those days. My daughter, who was turning one, ended up celebrating her birthday in Egypt.

After arriving in Holland, we stayed at a boarding house with all the other Dutch navy families for the first six months. We were overjoyed when we were given our first house in a small village called Voorschoten. It was a newly-built row of houses, all in the same style like the townhouses nowadays. I found it rather odd that there was no bathroom, only a small room with a washbasin and cold running water. You had to make hot water on the stove, which was electric, before you could wash yourself or the little ones! Years later, the council did put a hot water system, which was then a luxury, into every home.

In the early '50s it was common for most of the Dutch people to go once a week for a hot shower, and every suburb had a paying bath house. As a navy family, we were a bit fortunate because we were allowed to take our weekly

shower at the naval base which was in our village. It didn't cost us a cent, but we still had to go through all the hassle of dressing and undressing ourselves plus kids, and also walk a distance to get there. Especially in the cold winter months, it was no fun!

Every home had a coal burner which you had to get going every day. It was so freezing all over the house that I used to keep the little ones in bed until I got the one living room warmed. It took quite a while each day, so my first years in Holland were a really cold experience. It would freeze overnight sometimes, up to eighteen or twenty degrees under, so the windows got stuck. When snow fell, you had to kick the front door open to shove away the build-up of snow from overnight. It was pretty as a picture to see all the trees and houses covered in snow, but boy it was really cold. Coming from tropical Broome, I really had to adjust to that cold. Gradually, I got used to Europe, where I was to live for thirty years and increase the family by two boys.

In 1953 tragedy struck me for the first time after the birth of my third child, a son called Martino who was called Tino for short. I had my first big nervous breakdown. The breakdowns have caused me so much heartache and sorrow, I still find it difficult to write about them. I can only describe them as hell, living in a constant daze of drugs.

When I didn't pick up from the depression, they used shock treatment, which is the most frightening experience. To make matters worse,

the other patients having the same treatment are also scared out of their wits. The nurse took you to a small dark room where four nurses hold you down and put a long piece of rubber in your mouth to bite on. You lie on the table in the trauma of getting ready for the shock. Many patients would have to be dragged there by two nurses as the patient struggled and screamed. I would not wish it on my worst enemy. When it was my time for the treatment, I somehow managed to walk to that little dark room on my own, because I didn't want to put on a show. I felt a pride in not exposing my terrible fears and I didn't want to make a fool of myself, but only God knows how frightened I was. Even though I was to have two more breakdowns and each time was hospitalised for up to six months at a time, I was on medication and never had to go through shock treatment again.

The Dutch doctors who treated me were just great and I only have admiration for the hard work and treatment that they gave me. After three months they thought me fit enough to go home for a trial period. I tried to live as normal a life as possible. The medicine you have to take doesn't make it any easier. I wasn't home for long when I collapsed again and was hospitalised for about a year in all. No one will believe how harsh the nurses can be in those places. They would drag you by your hair and knock you against the walls in such a way that there would be no bruises or scars to show. When you complained to your family, they simply would not believe you.

I was only twenty-five years of age, and thanks to the love and help of some of my in-laws I managed to survive, and after a few years I fully recovered. The most important thing in my life has been my faith in God, without which I would not have survived the ordeal.

I concentrated on getting back to a normal life. I really had to force myself to do the daily chores of a young mother and wife. I haven't cried so much as I did in those days, mainly because of the helpless feeling one has over one's mind and body. The need to fight to do something about it was a mental strain. Only another person who has experienced a breakdown can understand your problems. It is very nerve-racking for your family and I am grateful that they have been so supportive. I find it amazing that, as it happened years later, my son Martino should choose to study and work with a team of doctors in Holland at the Psychiatric Hospital in Ermeloo. After all, it was after his birth that I suffered my big nervous breakdown.

When we were married in 1946, we only had a week's notice and had to be married in an Anglican church. Being a Catholic, I never felt it was the right thing, and even though I always went to church I never went to communion because I didn't have peace with my God. When I was in hospital with my first breakdown, I was visited by a priest every week and he persuaded my husband, for my well-being and peace of mind, to marry me in the Catholic church. Early one morning, we were brought to a convent not

121

far from the hospital. It was a very simple ceremony with only the nuns for witnesses. Once again I was able to practise my religion.

After leaving my parents and family in Australia in 1947, I finally had the opportunity to meet them again in 1958. My husband was still active in the navy and he was transferred to Dutch New Guinea with the children and me. I was relieved to be leaving that cold, cold country and going to stay in the tropics of New Guinea. The best part was being reunited with my own family, and my parents saw their grandchildren for the first time.

My father had gone back to the Philippines in 1949 after all his young life in Australia with its White Australia Policy. I assume that he left Australia in disgust after losing a court case in Perth against a man who cheated him out of the business they had set up together in Broome. (This man didn't live long enough to enjoy his ill-gotten business as he was accidentally electrocuted!) My poor old pop meant well in those days, but I don't understand why he took his wife and children, all younger than me, back to such a poor country. The kids were all Aussies and didn't know what poverty was until after a few years in the Philippines. I was lucky, I guess, to have lived most of my life in that cold European country, because even though I was lonely and homesick in those years, it was still better than the lives of my brothers and sisters. They went through hell and their stories are worth a book.

Those three years in Dutch New Guinea were one of the best periods in our lives. We all could live in so much sunshine, totalling more than the children had in their whole lives up until then. I look back with fond memories of the little island of Biak where my fifth and last child, Eugene, was born.

In 1961 we had to move back to Holland, as my husband's three-year tour of duty was over, and once again I was able to stay with my folks in the Philippines for two months. It was the last time I was able to see my father alive. I guess going back to Holland and feeling the loss of my own family were the causes of my second breakdown. I had to be hospitalised for six months in all, with medication but not the dreaded shock treatment. Luckily, I managed to cope with this and a subsequent third breakdown a lot better. I still insist that my faith in God is the key to overcoming any disasters that happen in one's life. Small or large, all problems can be rescued by one's faith.

My everyday life passed by with its share of ups and downs of a navy wife raising four boys and a girl, mostly on my own. My husband had to be at sea for a couple of months at a time as the children grew up. When I look back on some of the tough times, I have to admit that the efforts I made to make the kids into decent young adults has paid off more than I thought they would. I really do believe in the saying 'One reaps what one sows'.

The International Agriculture Centre (IAC)

was opened in 1970, about an hour's drive from where we lived in Holland. People from twenty different countries would stay for between six weeks and three months. We got involved with the Filipino participants and would bring them home. They loved being able to cook their own food at our place. I enjoyed learning to cook new dishes myself and over the years it has become one of my hobbies. When we would meet new arrivals, we were surprised that they already knew of us. We used to receive Christmas cards from all parts of the Philippines.

By 1974 my grown-up kids were working and earning their own living. They decided to give us a lovely surprise with a trip in 1975 to meet my old mother, whom I had not seen since 1961, just before my father died. My reunion with my mother was something no words can describe. We also met many of our friends from the IAC.

As soon as my children made the offer of the trip, I contacted my sisters around the world telling them the news. I had a response directly from two sisters living in Australia and one living in the USA and we were reunited in Davao City in the Philippines. I really looked forward to that month-long reunion because I had not seen one sister for twenty-eight years. I really thought we would have a beautiful time together after all that time. Little did I realise that it would be a disaster; the sisters from Australia and the USA could not agree with one another from the very start. It was such a disappointment and I had a great sense of shame towards my brother-in-law,

Polding Lopez, the Governor of Davao City, who was a gentleman in a most trying time. Up to this day, I cannot understand how two sisters could spoil the reunion to such an extent just because of their jealousy of one another!

The last five years I had in Holland were the most trying period of my life. I had to make a decision about leaving Holland for Australia, the sunny country my husband had always wanted to live in. I didn't want to live in Australia without our kids. I had been fighting for years not to break up the family in Holland and I had come to love that little country with its friendly folk. I felt at home there after the thirty years and I just wanted it to stay that way. By no means would my husband settle for my terms, so I was more or less forced to leave all my children behind when I gave in to his wishes. It broke my heart. I was hoping and praying that the dear Lord would take me away and end my sorrow but it wasn't meant to be that way. Now I see it as the Lord's way of bringing me back here to be useful to my sisters and brothers in a different way.

My husband could not enter Australia alone, because I would have to sponsor him. In spite of my hoping that grandchildren in Holland would be a joy to share, my kids told me to give him a chance. After all, he'd been good to us all and he never deserted me in all my time of sickness. My first granddaughter, Patty, was one year old when I left, and there are now five of them, and I haven't had the joy of seeing them growing up.

In the first few months here, I had practically given up hope of living a normal, happy life again. Thank goodness I had two sisters here who tried to comfort me in those first few months back in Australia. After one year in Australia, Tom, my fourth child and second-youngest son, decided to migrate here as a try-out. He's still here and it helped my survival. My eldest son, Michael, had promised to visit me six months after my departure. At the time that promise seemed to be merely to keep my spirits up, but he and his wife Maryann did come to visit us indeed. I really lived during their three-week stay, and the best news was that Tom was planning to migrate to Australia with his girlfriend. I was so happy that I could hardly wait for the six months of red tape and procedures involved in immigration to end. Once Tom started a new life here, I started to live again in the country of my birth. I thank God for being so good to me. No matter what is to come, I am as confident and strong in my faith as for the last sixty years.

Nowadays, I am glad to say that I am worry-free. I try to do the things that I enjoy, and up to now it has been working out great. When I started this story I had five grandchildren. Now I have ten, and three of them were born in Australia: Tom's daughter Chrissy is eleven; Eugene's daughters Saundra and Samantha are ten years and one year. These three little Aussies are my pride and joy and they keep me young at heart.

CECILY WELLINGTON

My Time Has Come to Speak

I was an Aboriginal childcare worker in 1988. I had just moved into a new housing commission home. I had saved money to buy my furniture and other household items and I was proud of my house and job. I was known throughout the Koori community as a happy-go-lucky sort of person. I've always wanted to make people laugh, and to be known for that. It used to make me feel real good. One of my hobbies was babysitting. I felt special knowing that the children's parents had a trust in me. Other than babysitting, I did the Aboriginal art of wood burning. I was also involved in the Aboriginal Women's Workshop, where the artwork and the atmosphere was fantastic.

All I wanted in life was to be happy. When I was a little girl, I can remember I dreamed that I owned a beautiful houseboat. I was on this houseboat floating slowly down this beautiful, wide, peaceful river with the shadows of the tall gum trees over me; that was my life for my

future. Well, I didn't get my houseboat but I did have a beautiful home; everything in my life was going fine.

Then I was a victim of a sexual assault. I don't want Koori women to think that women who are sexually assaulted have their lives shattered for life. It does take time to recover and there will be odium, but us women, we have a life too. We have our children, our grandchildren to look forward to.

A couple of times I tried to commit suicide but my children kept flashing before me and their faces looked so happy, filled with laughter. I gave up trying to end my life. My future with family will be a happy future, I can see it. I get this vision that life is far too important to end it over a horrible crime. I hope that on reading my story there will be understanding and hope.

We have to give life a chance. I know that I'm going to take that chance.

Christmas means getting together with your family and loved ones. In 1989 I decided to go to visit my family, who live in another town. I'd only got to know my family over the previous eight years as I was fostered out to a lovely white family when I was five years old (but that's another story). I'd go to visit my family when I had enough money or the chance.

Christmas time was lovely, just staying with

the family, enjoying that special day and night. But then Boxing Day came, and that night my nightmare began.

It all started like this. Seeing that I had Christmas with just the family, my brothers and sisters all decided to go to our cousin's place on Boxing Day. My cousin lived in a two-bedroom flat; there were six flats built on the one block and Koories lived in them all.

I'm not a drinker, but on occasion I will have a beer or two. Throughout that day and evening I had about nine small glasses of beer. I wouldn't have been able to handle a binge night. The company was grand, with people laughing and joking, and as usual me telling jokes and just clowning around.

On Christmas night, I had tried to ring my boyfriend up at home. I gave up and decided to wait till Boxing Day. I tried most of that day but still no success. I finally got him on Boxing Day evening and then the phone went all fuzzy. I tried to ring back but the phone was still on the blink. I decided to wait for another hour. It was coming on 10.00pm. I told my cousin I'd try again in an hour's time, if she was still up. My cousin told me, 'If the lights are all out, you know we are sleeping.'

I said to her, 'That's OK,' and went back to my other cousin's flat. I did check her flat about 11.00pm that night. She was asleep. I had this notion in my head to ring my boyfriend up. I was worried, as it was unusual for our phone to just go on the blink.

133

I asked my cousins where the nearest phone box was and they gave me directions. Before I went, my cousins told me to be careful and said I should ring up in the morning. I told everyone I was really concerned about my man.

They even gave me a time limit. I asked them what was going on. They said, 'You know your mum and dad are fighting with your dad's relations.'

I said, 'What are youse talking about? You are all talking stupid. I don't even know my stepdad's people very well. Why would they pick on me? I have nothing to do with the fight.' I ignored everyone and off I went. I went to the front of the block of flats, turned right, just like I was told. (I'm not familiar with my family's town.)

Even though I had nine glasses of beer that day and night, I was still very alert and aware of my surroundings. I was worried sick about my man. About fifty metres down to the right of the flats, there was a crossroad, with a wide median strip in the middle of a two-way traffic street. I crossed the road and I was on the median strip, getting confused with my directions. I finally gave up on the phone box. I was still on the median strip, walking back towards the flats; as I turned, I was grabbed on the left side of my shoulder and pushed to the ground severely.

There I seen two Koori men, a large, curly-haired, fat man and a thin, wavy-haired man. I thought for a moment of Abbott and Costello. I just couldn't believe that my own

colour would do such things. I was kicked and pinched; my left breast was squeezed very tightly. I couldn't think straight, but I had to do something. There were more than two guys. I heard other male voices in the background.

I was looking at the two guys I first seen and I put their description in my head and kept it in my mind. I couldn't describe the guys in the background. To me, the thin guy and the fat guy seemed to be the main actors, they were unattractive and seemed to be very ruthless and agitated men. Now and then I looked up into the sky. The guys started to get really rough with me. I was starting to get scared and I wanted to scream but couldn't —all these questions filling my head.

The men grabbed my clothes and started to drag me around like a rag doll, my clothes getting torn from my body, my T-shirt ripped, my track pants torn and my underwear ripped. I kept wondering what was going on. I was swearing and crying and saying, why me? What did I do wrong? Who are they? For about five seconds, everything was quiet. I was lying on the ground; next minute, I had my legs open. I felt two hands on each one of my legs. It wasn't the fat or skinny guy. It was two other guys, they held my legs so tightly. Then out of the blue, a blunt object was pushed up underneath my chin, very firmly. I couldn't scream, I was thinking about the movies—how you see women screaming, yelling, when they're attacked. Real life is a different story.

The fat guy got on top of me and put his

fingers inside my vagina but I tightened my muscles, I wasn't going to be beaten. He put his penis inside my vagina but I was desperately fighting, flexing my muscles, my legs getting sore. I didn't want these mongrels to beat me. The thin guy wanted to have a go. I could hear him swearing, telling the fat guy to get off and telling him, 'I want a turn too.'

Meanwhile, the other guys were calling me names like you black mole slut, you need this rammed right up you. I felt interrogated, especially when the guys asked me if I had brothers and sisters. I said yes, and when they mentioned my eldest brother's name I was so shocked. Then they asked all these questions; my head was getting so confused. At the time I didn't know if I was Arthur or Martha. I was bleeding from the mouth; my hair was so knotted that pieces were falling out; my left breast was sore; my legs were so tired. Eventually I gave up struggling, I couldn't fight anymore. There I was, just lying there. I couldn't believe what I was doing.

Then all of a sudden, the fat guy and thin guy jumped up from on top of me, the other guys let go of my legs. I just lay there, not daring to move. I gradually got up and looked around me. I was feeling so embarrassed, yet so dirty; so guilty, but innocent. I thanked the dear Lord. Then I got up, wrapped what clothing I had on me around my body, then ran straight back towards the flats. I collapsed at the front of the flats on the footpath.

A weird thing happened, my cousin just

happened to be at the front of the flats, he picked me up and carried me into my cousin's flat and put me on the lounge chair. I was so tired I wanted to go to sleep. I was getting questions left, right and centre on what happened. I told everyone to leave me alone—I just wanted to go to sleep but the questions were still getting put on me.

My cousin wanted to get the police. I didn't want no police, but then I was getting upset, so my sister-in-law took me to the hospital. At the outpatients, the sister on duty was very concerned that I felt protected; her soft voice showed what a kind person she was.

The police came, two male officers. They started to ask questions. I was getting embarrassed talking to two male police officers. I was going to tell them to go and leave me alone, but I kept my mouth shut tight. The doctor came in and I was glad, even though he was male. The police waited outside while the doctor was seeing me.

I was nervous talking to the doctor and I didn't want him to poke me anymore. I was sore enough. I made my first bad mistake, I didn't let the doctor examine me fully. I didn't tell him I was sexually assaulted. I didn't want to talk to him at all when questions were getting personal. I was shy, so the doctor didn't do no more examining. I felt so dirty down below.

After the doctor finished, the police came back asking questions. It seemed to me that the questions were repeating themselves. I just wasn't thinking straight. The sister came in and looked

137

at me, then told the police I needed rest and sleep. I fell asleep.

Next morning, I woke up very sore and my legs felt like they were crushed. The police told me to go to the police station to write out a statement.

My sister-in-law picked me up, then we drove over to where my mum lived. On the way over, my sister-in-law told me that there was a brick thrown through their window in the early hours of the morning and she heard a voice calling out, 'We got one of yours!' I was already in hospital, so my sister-in-law knew who they were talking about. My brothers were furious.

We went to see a detective to make a statement. There was no policewoman present and I can't recall the detective asking me if I wanted a policewoman present. We had to walk up one flight of stairs. I was getting weak and felt that I had no support from the police at all. My mum walked behind me, making sure I wouldn't slip.

I sat down, with my mum standing behind me. The detective asked me questions. I thought about the police asking me questions in the hospital. Oh well, I thought, here I go again.

When the detective asked me about what the guys done to me, I didn't tell him the truth. I told everything else what had happened. When I wrote my statement, I left the most important part out. I felt very embarrassed and shy, especially talking to police.

My mum went out of the office and the

detective gave me a couple of mugshot books. I noticed a couple of guys who looked very similar to the fat and thin guy. The detective told me that one of the guys didn't live here anymore. I just repeated myself and said that they looked similar. I asked the detective should we see if we could spot these guys around town and he said yes. The detective was finished with me and he told me to contact him as soon as we seen them.

We went back to Mum's place; Mum told me to stay home for they knew who they were looking for. My brothers knew I was still tired and very sore so I lay down, but before I did I asked Mother to ring my work up and tell them what happened. Mum done that and she told me everything was alright.

Dad was trying to clue everything together. He suddenly clicked, and it was because of a stupid, hideous family feud which occurred years ago. My family never bothered to tell me about the feud at all, for it had nothing to do with me. I was in the wrong place at the wrong time.

All this made me wonder why people want to hurt other people. Women are allowed to walk at night; why do we have to peek around corners?

I spent another week with my family and tried to rest as much as possible. I can remember my son telling me, 'You go home, Mummy, I'll be alright and make sure you're OK.' I went home

after New Year's Eve. The train ride was very bumpy and people were looking at me. I felt that I was getting interrogated by everyone. My family didn't have a car to bring me home.

When I'd hear about a rape or attack on a woman, you see their photo and the women are beautiful. I'm not an ugly woman. I'm not a beautiful woman either, but I do have a lot of pride in myself, and self-respect.

I finally arrived home after six hours on the train. My boyfriend met me at the station. He was shocked and angry at me but was glad that I was OK. He gave me a big hug and we went home.

After we sat down together and I told him what had happened, he was very stirred up and felt like going and killing those mongrels. After me calming him down, he agreed to wait to see what the police came up with.

The following week, we went to my boss's place. I no sooner opened the car door and my boss told me straight, 'You are sacked!' I couldn't believe my ears. They already got someone else to do my relief work.

I felt then and there that, because of the rotten bastards who attacked me, my life was going to be torn and shattered. After my mum ringing up, you'd think they would've been sincere. I went to the Aboriginal Co-operative and I explained to the directors what had happened; they understood and I got my job back. But by then I was starting to get very upset and bewildered by what had happened to me. I started to get nightmares, started arguing with friends

and especially with my boyfriend, neglecting my home and my garden. My boyfriend would blame me for all of it; he'd say things like 'you probably wanted it'. I understood him and I didn't blame him one bit for being angry with me and wanting to leave me.

He finally left me and I was feeling shut out by everyone, neglecting my friends. I could see myself deteriorate. I started to hit the booze, and not being a drinker I was getting sick quickly, and being a diabetic it wasn't doing me any good. I can remember one night I was home alone, getting over the booze. I knew I had to wake up to myself and fight this, yet I knew I'd have to live with this for a long time. I heard a knock at the front door. My boyfriend came to apologise to me for how wild he was and said that he will stick by me through this. I was so happy that he still loved me. A lot of men tend to leave their loved ones over crimes like this and it's very sad.

Day by day, we would cope with the house, garden and friends. My nightmares were getting worse and I soon started to go downhill, neglecting my rent and my car loan payments. This time I knew I was falling fast, but I had my boyfriend beside me. We decided to move and leave all our friends. I needed time out from all my people and friends; my boyfriend thought it was a good move. We let all our furniture go, and personal belongings were just left behind. I knew what I was doing but there seemed to be a robot controlling me, it was unbelievable.

Before we left, I was seeing a female doctor

at the Aboriginal Medical Centre, who referred me to CASA (Centre Against Sexual Assault), which was luckily also in the same town where I lived.

I had several visits with CASA and I was feeling better within myself. I received a lot of advice and understanding; the only problem I could see in these centres was that there were no Koori women counsellors. Perhaps there are now, but to my knowledge there were no Koori counsellors at that time. We should have Koori counsellors in these centres all over Australia. I know we have Aboriginal medical centres, health centres, Legal Aid. I'm really proud of all these centres and I'm proud to be Aboriginal.

After a while, I started to lift myself up. The visits with CASA did help. I was admitted to the local hospital for nerves, having nervous breakdowns and needing time out. I also seen a psychiatric nurse and she had done a couple of home visits, which I was grateful for.

I really didn't want to leave town but I felt I had better go, even though I had all the help I needed. We finally settled in our new surroundings. I went to pick my son up. I only stayed about an hour and we left straightaway. My boyfriend had cousins in our new town so it felt better knowing someone else in the area. I even joined a hockey team and made lots of white friends. Everything was looking good.

After a couple of months, I started to fall apart. CASA had a special doctor for their clients. I went to this special doctor and he was very

understanding. He could see me falling to pieces and knew I needed time out, so he put me in a psychiatric hospital. I was nervous because I thought these psycho hospitals had weird people. I was thinking of people walking around with straightjackets, and funny old women in rocking chairs laughing, but the hospital was set on this beautiful block. The gardens were beautiful, there was no fence. In the middle of the garden stood this lovely big old tree. My first visit there was only four nights. I just kept to myself. The second visit was for two weeks. I made a couple of friends and there was this large craft room.

We'd do painting, drawings, singalongs, mimes, and so on. There was another girl in my situation and before we'd go to bed we'd sit on the wooden chairs and talk to each other about our problems because we wanted to see if our thoughts and feelings were the same. We're now good friends and see each other now and then.

After getting out of hospital, I kept on seeing CASA and the doctor. I'd still have trouble with nightmares. I just couldn't get those mongrels from my mind, even when I'd go shopping or sit watching TV, and, worst of all, when I was in bed. I'd get visions. A few times I've scratched my boyfriend and his hair. I nearly choked him. I just couldn't believe what was happening to me. Why do women in these sort of crimes have to go through hell?

It was a year after it happened. I told my counsellor from CASA that I was going to visit Mum for Christmas. It was something that I had to do. I only stand five foot tall, but I stood seven foot and felt very brave going back to where it happened. So did my boyfriend. We arrived a week before Christmas Day. I visited my cousin's place twice and looked up the road a couple of times. I was feeling brave, especially with my man beside me.

Christmas went well, and a week later my youngest sister said, 'Sis, I've got something to tell you.' She told me who had set up the assault on me. I was devastated to have it come from my youngest sister. Two of the guys were my stepdad's cousins. She said that one of the Koori girls met Mum downtown and told her who done it. The guys were bragging to other guys what they done to me. I wanted to go to the police straightaway. Mum said no, for I'd start an argument up with my brothers. She repeated herself and then told me to shut up in a very rough voice. I felt that my family wasn't worried about me, only themselves. I was getting really upset with my family.

We stayed for a couple of days, then went back home. I couldn't take it any longer. I didn't tell my boyfriend until we got home, and he was furious. I calmed him down and explained to him why I couldn't tell the police.

I didn't see or hear from my family for two years after my nightmare. I didn't go to visit them for a long, long time, and the only time I saw them

was at a funeral. I could not face the fact that my family didn't care about me.

I decided to go and visit my counsellor and she was shocked to think that my family knew about it four or five months beforehand. I decided to see the police, so CASA arranged for me to see a policewoman, who was really nice. I told the policewoman the truth about what had happened and also who the guys were. She rang the detective, who took my statement. He was very rude to her and she told me that he said they had closed the case. I was so upset; the policewoman was angry. I felt that she had sympathy for me, she was so understanding. I had my moments of crying and left her office. She wanted me to see her again.

I kept thinking about why they closed the case. I was pointing at prejudice because of Koori against Koori. At that moment, I really hated the police.

We decided to move back home, back down to where all our friends were. We had made a lot of friends already and it was sad to leave them. But before I left, I put a claim in for crime compensation. It took me about four months to decide whether I needed it. I finally did it by getting myself a solicitor through CASA. Without CASA I would've been lost. I felt good to think that the Centre helps people to regain their strength and start a new life after time lost

suffering pain. I felt guilty doing it, but I didn't have to think I'm greedy. After all, I didn't ask for it.

Court finally came. I had been waiting for two years and it was like waiting for ten. My solicitor contacted me and told me when court was to be on; it came up all of a sudden. I had two days to prepare myself. I was so nervous.

I met my solicitor at court. He seemed to be so relaxed, and there was another solicitor, he was relaxed too. I was so frightened but my solicitors were so protective and concerned, I felt somesecurity. My CASA friend also attended and gave me a big hug and told me that it would be tough in court, but to hold my head up high. I wished it was the committal hearing but it wasn't. It seemed like hours in court but it took about thirty minutes.

I walked out all confused but relieved. I sat down in the waiting area, left alone for about five minutes to recover. Tears just rolled down my cheeks. My solicitor came over. I thanked him and the other solicitor. They both sat down beside me and explained that the judge wasn't clear on what had actually happened. Why didn't I tell the police the truth in the first place, and why didn't I tell them who assaulted me? I explained to them what my family had said, and I also told them about the policewoman I spoke to. See, I was told not to say.

Court was delayed for one hour, which made me worse. I started to crumble. My legs shook like jelly. I entered the room with my solicitors

and my CASA friend was allowed to come in. It was a closed court, only the judge, solicitors, myself and a friend. My CASA friend had to go, which was sad, but I asked if my aunty could come in. She was allowed, so she sat next to me.

Questions began from my solicitors. I kept staring at the judge. It was like I was in a trance. I kept on wondering what was in the judge's mind. He was so clever, I knew he'd get to me. I started to crumble, even though I was only going for compensation.

My solicitor then got a writing pad and I told him who assaulted me and I signed below. I really confused the court, that was my big mistake. If only I had told the police the truth in the first place, but I was so scared. Throughout those two years I had been looking over my shoulders and I'm still doing that. I felt that I was rushed through court and I didn't prepare myself properly. I wasn't satisfied with the judge's comments but that was the law. He spoke as if I was the criminal and talked about how I had been drunk. And he described the men as being my own people.

Still feeling the pressure, I kept on wondering if I should appeal. I was satisfied with the amount of money the government gave me, but wasn't satisfied with how I was treated. I did neglect the most important parts of this crime. I'm paying for my stupidity, but I wasn't going to let those mongrels get away.

I love my culture and my people very much but I wasn't going to have this on my mind for

the rest of my life. I blamed my family for telling me to be quiet. After all, I was the victim, though I sometimes felt like the criminal.

White men rape white women and they get caught in most cases and justice is done, but when Koori men rape Koori women, we tend to hide this. There are a few Koori women I know who have spoken out against their own colour, but there are a lot that are still hiding behind closed doors.

I spoke to a couple of my elders about this sort of crime. They told me that it's hard to turn your own colour in, in some circumstances, but a crime like this you have to tell police, for those guys could hurt other women. They understood my problem and why my family told me to shut up. After speaking to my elders, I decided to appeal. I finally went to court again and everything went a lot more smoothly. I was happy because there was a different judge and I could speak more freely. I had my say fully and felt that I got understanding from the judge, even though the men didn't go to trial but went free. I have to live with that.

Following the nightmare and the court cases I moved interstate and left my relationship— because of what happened to me. I'm now happily married and my artwork has come a long way. My children are teenagers and it makes me feel great to see them around me. My first grandchild will be born soon. If I had done those crazy things to end my life I would never have met my husband and seen my children grow up.

I hope that on reading my story there is a lot more understanding and awareness. We don't need to be tormented. We have our families and friends to share our lives. For those women who have stayed behind closed doors, open that door and tell someone what has happened, for if you bottle it up in your mind you will be a very confused person. I tried to do that a couple of times but I wanted to get help, and I'm so glad I did, even though I made mistakes. This crime has to stop, and to stop this sort of crime we have to bring it to justice, no matter who has done it.

LORNA COX
One Step Ahead

LORNA COX

One Step Ahead

Pressure

It was a promising relationship
It was rich in its bearings
Me and him we'd go fishing
And our relationship was so close together
that everything was.
The three males
The other two girls
We were living in the dormitory
And they'd carry on,
Whatever,
In what way
But the thing was
We weren't allowed to see each other
If we saw each other
It had to be in daytime.
We were in our teens
And he—Fr Dominic
Would always come over and tell us
To get out of the mission.
He didn't want anything else, like,
happening
He'd ask us to leave.
It was like somebody was spying on us

And anything we did,
Which in the eyes of them
They didn't like,
We were supposed to get out,
Immediately get out of the place.

He pushed us that far—
I'm not sure whether it was our family,
Or from both families, right?
From both sides.
We were always saying back to them,
That I had my rights.
It became that we had to do something about
our relationship
Because we couldn't stay there.
Everytime we came in—
Especially me—
When it started
I was a Broome girl,
A Beagle Bay girl who had been away
to Broome.
There were times when I'd come to the
front gate
And he would say,
'All right,
I don't want no funny business
happening here,
If anything happens out of the ordinary,
You have to leave.'
This was coming from the mission priest!
Then we just left
Ken, Catherine, myself, Luke and Jimmy.

We decided to move out of the place
and find our own.
I went to Derby
Near my partner.
Catherine and Ken went to Broome
They ended up getting a house
And they were doing OK.
So we lived together for four years,
Not a bad time after Beagle Bay
Everyone got a job and lived their own way
of life.

The family started worrying about us,
Our welfare,
And wanted to know what we were about
How we were getting on.
There was always that nagging
That we had to get back to Beagle Bay
So everytime we'd go back to Beagle Bay
We'd have to pass through the main office
And tell the priest that we were there.
This would happen to everyone
in the community
You had to get permission.
We couldn't avoid it
We'd be found out anyway.
So everytime we went back there—
To Beagle Bay—
We had to stop at the front gate
And more or less tell them,
Make yourself known,
That you were there

And then you wouldn't get into trouble.
And everytime we'd go to see our
families on weekends
The priest would say,
'When you going to get married?
You can't live like this
You're living in sin
It's bad, no good—
Your families are Catholics, might as well.
They don't agree with it.'
But they couldn't push us that far
Because you can't push someone,
you know,
We've got to find out for ourselves
Where we're going
And they,
They don't know everything about it.

Pushed Into It

We were pushed that bad
That it ended up
Us getting married,
And he asked whether we'd have a
double wedding
Or marry us all off at the same time
And we said, 'No.'
We disagreed
We didn't want to get married yet,
We were still finding what life
was all about

And he'd go and ask the family.

Everybody else wanted us,
The priest
The family
Pushing us,
And I said, 'Ohh.'
As I told you, I was under the welfare
And Sean O'Day was my welfare officer,
And he'd come out and see me.
He knew what had been happening
The pressure we'd got,
The people
The priest
And he said, 'Oh well, you can't do this,
You can't get married,
You're too young.'

Then one day he came
I was sitting at my front door.
We were talking about myself,
I was seventeen.
He said, 'You've got eleven days to go
And you'll be eighteen,
Out of our hands.'
And it was all push.
Not being able to make up your own mind,
you know,
Your own doings
Where you're going
What you're doing
How you want to do something.

There was always someone wanting to make
our minds up for us.
In the end
We eventually got married.
I can remember how it was
Eleven days after I turned eighteen.

Because the pressure was so great,
None of us really knew what we were in for.
When we were married,
We had everything provided for us—
House, cooking utensils,
Everything
The whole works
Including beds
Given by the priest and the families.
The community.
We were Catholics.
We had family help as well.
But then when things all fell into place
We were very young
My first child came
Unplanned.
Suddenly, *'Ohh, you're pregnant.'*
We got married
We had a double wedding
We didn't make up our own minds
We were told that we were going to get
married
And so we were married.

Seriously, looking back now,

The two actual pressures that made it hard
for us to cope
Came from the community
And the church
Then of course
Three of us were pregnant when we
got married.

The Good Times

Um, I don't know really what to talk
about now—
No, well I'll tell you this bit,
I used to be at Beagle Bay at one stage
And my marriage busted,
You know, busted up
And I just had to move out
and forget the past.
If I'd stayed there
I would've just wrecked my brains
'Cos I was already really nervy.
I used to take Valium and that
I really buggered myself out.

Anyway I took off to Derby
Six months later I got a house
Because you only wait six months.
Got a house, stayed there with my little gang.
Everytime I used to go back
Take the kids back to see their people
I used to make it a rule on Wednesdays

Travel on Wednesday nights or
Wednesday afternoons
After a good card game and go back
Drive all day
Get in there late
Pick up maybe an extra jerry can of fuel
And go straight out to Beagle Bay.
All this time I've been going
I used to say to my friends,
'Why don't youse come up to Derby and
grow up.
Mix and be sociable, and learn what outside
life is all about?'

I took this girl, and she came with me
She found a bloke
She settled down
Didn't take her long to settle down.
Then, another trip came up
I used to do my trips often,
That's for my kids' sake, see
They always wanted to go back and see
their nanna.
I made it my rule
That I should be a little bit more considerate
As well as thinking of myself.
So we went back and I picked up, um, Teresa
And we was there in Derby for a while
And she started getting popular with
everybody else
And they got popular with her.
She found it was good—

good, you know—*really good*
The going was good
And then she fell out of hand
And she was in the wrong hands
And she struck trouble.
The trouble was she fell pregnant,
So she went back home after she found out.

Another time I went to Beagle Bay—
I used to do that all the time, see
Go back again
And the girls would say, 'Hey, how's Derby?'
'Great, boy, you gotta be in it, you know,
to win it.'
'Ay, you wanna come or what?'
And they say, 'Oh no, Derby's slack, no blue
water, no nothing,
Nothing good there, just dry, big marsh—
Hot country.'
I said, 'Look, best thing you find out what's
there before you can say.'
So anyway this other girl I brought with me,
Her name was Sarah
She used to stay with me
And then she got popular
And she freaked out.
She wanted to go all over the place
And she was running wild
She had no ties
Then she copped it.
And when she copped it,
it was too late to jump back

She got pregnant
So everyone that I took there, they all found
a mate
And they said,
'Oh, Derby's a rotten place, I don't wanna go
there
It stinks
Too hot.'

Jealousy

I used to love going out
But I was with Johnny at the time
And Johnny is really jealous.
All Johnny wanted to do was rip me up
on sight
If I did anything wrong
And I didn't know I was doing it wrongly
And he saw me doing it
And he didn't like it—
Like sometimes, I'd get off hand laughing and
that—
He'd think I was trying to catch the eye of
somebody else
Then I'd cop it.

They all miss that now, these girls
'Cos they gotta find a babysitter
To take a round trip all the time
Well, I had my own kids
And my aunty used to come over
and babysit 'em

And I used to go out.
I couldn't go out very much
We'd go out for ten minutes
And Johnny would say, 'What the fuck's
going on, man?'
And then all of a sudden,
'Get your bag, we're going home.'
Only ten minutes in the pub
And then we going home.

I really tried hard 'cos we was going steady
for three years
We used to go on and off
Break up and go back
Break up and go back
And I thought, 'Ohh—
If I played my cards right
I'd stay here and he'd stay somewhere else.'
When I did, um,
He thought I was messing around—
I was too—
I was trying to get rid of the feeling of it all
And he was making me feel sort of easy when
I saw him
And I missed him.

I was in Broome and he was in
Beagle Bay then
And he said to me—he sent a message
for me
And asked when I was coming back.
'Oh, next pension week I'll be back.'

Every pension week I was going back
but I never went
I never went back.
I was trying really hard
True
It nearly killed me
And I tried harder, really hard
to stay away from him.
And, um, he said to me,
'You gonna come back to Beagle Bay
Or do I have to come to Broome
and pick you up?'
'You don't have to worry about
coming to Broome to pick me up
I'll come there myself.'
So he said alright
He took off back
I bought him half a carton to make
him feel good
And I had a full carton when he went back.
Waiting and waiting
And he didn't come back
He didn't know what to do, he was lost
All that time he was waiting for me,
he was lost.
He used to get a big double bed and
everything in the room
Video, TV
All my stuff, you know.

The Bust Up

I played my cards right
And I was in Broome and he was there.
When he came,
He was just like a stranger to me
But he always wanted me to go back.
And he said, 'You better think about it
before you say we gonna finish.'
I said, 'I been thinking about it
for six months.'
And he says, 'Nuh, all you want is
to go pub, get drunk,
Smoke dope and act the goat.'
'That's not true.'
I have been doing that
But not very often
I couldn't and, um,
He says, 'Well, what do you wanna do?'

He comes in on Friday,
One Friday he comes in
That was Christmas time,
Two weeks before Christmas, he comes in
from Beagle Bay.
'Ohh, Lorna, I wanna talk to you please.'
'Yeah—
If we gonna talk something serious
We better go somewhere, talk quietly
I don't want no hassles in between
anybody's house.'
So we went away

165

Had a talk.
We had three hours of talk
I couldn't believe it
He tried to persuade me
And he reckons if I'm clever enough
I might be doing the right thing.
But he thinks that I was just overreacting
I was trying to have something that I couldn't
I said to him, 'It's what I want
So it's best if we be really close friends
And help one another when we can.'
And I've been doing that ever since I've been
finished with him too,
Giving him money and helping him out
And, um, he says to me, 'OK.'

So we busted up
We went to the pub that very night,
after we finished up
He was a completely different bloke
And I was like this,
Scared
'Cos he told me before he left,
'Whatever you do, don't walk
in front with a bloke
Or don't ever talk to him in front of me
'Cos I'd just go bananas.'
I know he would too
He'd punch me right there
So I just kept away.
I was standing there
And he was down dancing on the floor
I had the urge in me to go to him, you know

And say hello
And talk to him
But I just sorta held myself back
And he walked away
And he saw me
So I just got in a taxi and I went home.

And since that night we finished off
He's been with—
That same night—
He's been with Elaine ever since.
But everytime he walks into the pub
And I'm there
He walks straight out
'Cos he knows he'll just go bananas,
Or if I'm walking into the pub
And he's there
I walk out.
He's been really good
But soon as he hits the drink
That's it
Bang, smash, crash, you know.

Fear

If you decide to stay
And live in fear all your life
And you can't overcome your fear,
Do something about it,
Then you are stuck
'Cos he'll always make sure
That every little move you make

He's there.
When he found out I was working
And he was in Kununurra
He came back.
He found out I was working,
and was really happy about it.
Maybe he thought I wouldn't
make an effort
I'd be with Dotty and them
Having a good time
Chasing the guys from
the deep blue ocean.
He would get really mad then
But anyway, all that's in the past
He still says that if I do something in front
of his face
He's going to bust me up.

Whiteman's Bait

If they wanna talk about us like that,
Rubbish us for nothing
Just plain jealousy
Because they see that they are one step
behind
And we are one step ahead of them
And they can't tolerate that sort of thing—
It's like how they call us
Whiteman's bait
We are what we are—
If they can't accept us
Too bad.

From their point of view
I'm not allowed to go with white guys
Because I'm a half-caste girl
And a half-caste girl has to
go with a half-caste boy.
And a half-caste dickhead
on Sunday told me
He wanted to go with me
And he's determined to win me.
I was there with Steve—
He's done it to me a couple of times now—
When I was with Steve,
He tried to punch up Steve
with all his gang
There's eighteen of 'em.
The Sunday just past
He said to me, 'Ohh, look Lorna I want to,
um, I want to go with you.'
And I says, 'Look, I'm not interested, just
leave me alone.'
And he says, 'Ohh, you being smart ay!
So you go with white man.'
I said, 'Look, I am what I am
If you don't like it you can lump it, OK
And just let me go!'
He says, 'Nuh! When I want you,
I want you.'
I said, 'You got no claim over me
Just get out of my life
If you don't
I'm gonna call the cops and tell them
you're hassling me.'

The last time he wanted to punch me
at a party
He was fronting me up
And I just told him to buzz off
When I walked away.
I was walking off home
And Peter, the policeman,
Was on duty that night
And he saw this, you know,
He saw everything that was happening
And he asked me if I was alright.
I was in a bad way
I was falling over
I just walked away and Peter says,
'Ohh, leave her alone before I chuck you in,
You gonna be another
If you gonna try and be smart with her and
I'm around
I'm just gonna throw you in.'
I said to Peter, 'Anyway, I'm gonna go home.'
So I walked off home and
Peter comes behind
He gave me a lift and dropped me
off at Aunty Dotty's.
That was on a Saturday night
And last Sunday night
Here he was getting smart with me
Determined, you know,
He was gonna make it out with me.
I told Steve
And he's gonna go and punch his face in
And see those guys.
Oh, these guys had a gang of eighteen

And they was gonna do a punch-up
against the mines.
See, Steve works for a mining company
And they was gonna punch up Steve
and all his gang,
Steve hasn't got a gang
It's just they all are good friends
And they work together
I know 'em all
We all used to muck around together
They were with their girlfriends
And me and Steve.

Everybody was aware what was going on
The bouncers and all
Even the TI * boys was on our side
But after I told him to piss off and leave me
alone
He was gone about twenty minutes.
After he said, 'You not gonna stop me.'
Then he walked off.
That's why I'm a bit scared to come to the
pub by myself
If I know my cousins are in it then I'll go
But if they're not around
I won't go anywhere near
Or if Steve comes around
See, Steve usually picks me up on my long
weekends
And he'd stay
But this is an ugly sort of attitude
Because it's not right,
It's sickening really. * Thursday Island

171

But all these girls who used to rubbish me
all the time
And call me names
I used to walk through the pub.
You know how you walk through a whole
lot of people
Standing, drinking and laughing and that?
And as soon as I come into the picture
They swear me out—
True
Call me all the filthy names under the sun
And all I wanted to do was shrink
But instead, I just walked off
Put my nose in the air
And I walked in like a snob.
And someone says, 'Lorna, so-and-so's
abusing you.'
'Tell her to go and get bloody lost,
or get ripped.'
And they always used to whisper,
'Oh, I'll get that fucken Lorna
She thinks she's just it.'
And that's a sickening way of doing things.
I went to them
Those people involved
And some of them was with their mothers.
I couldn't take it anymore
I went one time during work
I went there
And I just told 'em what I wanted to say
And then I went to the cop-shop
And I said, 'If these mob gonna

give me trouble
I'll give 'em trouble
But if you guys are not there
Too bad
Because I'm gonna lose my head
And just go right off.
I'll kill somebody
I will
Even if I have to break a glass
And slice his throat
They just wanna drive me insane
And chuck me off the shelf.'

Now

I even sort of cleave to myself
Within our family circle,
Not very much of a family support.
Everybody drifted away, you know,
We don't have that much anymore.
Too much, in later years,
Everybody going their own way
Learning about the outside world.
I believe in working
As a means to be independent,
Rather than always having to rely
on other people.
Before, I've always believed in
being independent
Being, rather than sitting back
and waiting for things to happen,

Rather than going along with it,
Do something about it.
My past wasn't too great a concern for me,
My feeling
That if I go back
At least it would be good sometimes,
And other times could be bad.
Then I say, 'Well, I do my job
I have to do my job.'
And I'm going to carry out my duties,
Whatever,
Despite anybody else saying,
'Ohh, you can't do that!'

ALTHEA ILLIN

Time For a Change

I was born in a little Aboriginal mission in 1949, to my mother Anna Laurel Palmer (nee Fourmile), who was married to Cedric Charles Palmer. Both my parents were born in Yarrabah.

My mother's mother, Nellie Bradley, was born on the beach at Fraser Island, because in those days the blacks had nowhere else to run so they ran out to the sea, and plenty more were probably born there too. Nellie had an Aboriginal mother and a German father. The whitefella later sent her away from her family. My grandmother had other brothers and sisters. She later married Charlie Fourmile, who came to be known to me as my Popeye Charlie. My Popeye loved us all. I am trying now to trace my ancestors. My Popeye came from the Barron River, Redlynch Tableland mob, and the Fourmiles got the name from living in and around there—it was four miles to Cairns.

Yarrabah is about forty miles from Cairns, very beautiful country. I believe it's classed as God's own country—you'd better believe it! My dad's parents—well, his father, Charles Palmer,

is Kalkadoon, which is the Mt Isa area. He was born in Cloncurry, Queensland. He had a white father and an Aboriginal mother. Grandad had a half-brother, Billo Skulthorpe, and their father rode in and owned a rodeo show out in Cloncurry. They had different mothers. My grandad was sent here with his mother and brother. He also had a sister, but they do not know what happened to her. Later Grandad married Irene Choikee, whose mother came, or rather was sent by the whitefella, from Cooktown.

The whitefella sent my great-grandmother, Ada Choikee, with her mother and adopted son to Yarrabah. Her adopted son was Peter Underwood, who was saved by a whitefella named Jim Underwood. Jim was a pearl diver and was married to Granny Ada's mother, Emily. Peter Underwood would have only been four or maybe five years old, and also was known then by the name of Tar Bucket. The police had him clinging to a drum either on the ocean or some pool of water, and were going to use him for target practice. In those days, a certain ship went down, and Jim Underwood was asked to go and try to retrieve whatever. He came up with a gold compass, which is in a museum down south somewhere. There is also an anchor in Cairns which came from the same ship.

In those days in Yarrabah, which was a Church mission, you could not fall in love or have sex without the priest, Father Brown, marrying young couples. It was impossible to have a white wedding or even to

get married in the day, only at night.

My grandfather was a carpenter. I remember he used to be always building boats and houses. One day my grandfather had an argument with Major Wakefield, the superintendent. To punish my pop, the Major sent for an Aboriginal police escort from Palm Island to come and take him away. So my father and mother, my eldest brother Brian, Nerida and me had to go too. I would have been three, my brother Brian would have been seven, and Nerida would have been one.

So life begins on Palm Island. I can still remember my kindy days very clearly. If my grandparents thought they had it tough in Yarrabah, wait till they got to Palm Island.

The whites had a curfew on, so that no blacks walked around after nine at night. When the first bell rang you had to make your way home. When the second one rang you had better be in bed, otherwise you'd be in gaol. If you were fishing, you had to have a pass, no matter what the reason. If you weren't in by six o'clock, it was gaol again.

The whitefella rationed food out to each family according to its size, one day a week. There were many times I carried a pillowslip of meat and bread home. I would have been about nine or ten, I'm not really sure. Anyway, once a week the blacks would get tealeaf, sugar, rice syrup, salt, flour, creme of tartar, baking soda, and some fruit and vegetables. My aunty thought that maybe it was coming out of their endowment.

When I was small we never had dolls to play

181

with, only the rich had dolls. We played with bottles. We did a lot of swimming. Every child on Palm Island was a good swimmer—we grew up in the water.

There was this man over there who worked for the police, George Reed. God knows how many kids felt the bite of his tongue and strap. He never realised we'd make good swimmers one day, we weren't allowed to play on the beach without our parents or a grown-up.

We had a German headmaster at our school on Palm, he taught my aunties and uncles, and a lot of other people on the island. He also taught me, my brother and a couple of my sisters, Nerida and Elvina. We also had another brother, Charles, who died of bronchitis when he was only four, I think. That was a very sad time for all of us. It broke my mum and dad's heart, and also us kids'. Gwen was only a baby but she would always be looking for my little brother everywhere she would go. She even tried to dig a hole to look for him when she couldn't see him. I believe children shouldn't go to funerals.

Somehow us kids always seemed to end up with our grandparents looking after us. My granny had beautiful roses. I remember us sitting in her garden spinning yarns, or rather they always seemed to make me the centre of attention. I was always getting into my grandfather's tools. I always wanted to be a nurse and a country and western singer. I used to get the nails and poke them into my sister's ears or

bum. I'd also use lemon-tree thorns for needles. I used to tell them that I was their nurse and they actually believed me.

I reckon I could have made something of myself if my teacher, Mr Kraus, gave me some recognition. I was a very good swimmer and I'm not too bad at English either. I was a good learner. I was in the hospital in Townsville with a false appendectomy when I was about thirteen. When I got back to school I had missed out on my exams and Mr Kraus wouldn't let me have them. I stayed down in the same class again. After that I felt really let down, as my mum and dad weren't there, and I sort of lost all hope in learning.

The day I came out from the hospital, the nurses dressed me in an old pretty night-dress. They put ribbons around my shoulders and waist so that it could fit me. No pants on, you could see right through it. I remember when I was climbing up the jetty, there was a couple of blokes trying to look up my dress.

When I walked through the gate at my grandparents' place and they saw me coming, they started to cry. I cried too. My aunts are always telling me how I used to act when I was small and we'd all laugh. I'd feel a bit shame. I was always seeming to cop it all the time.

All us kids were living with Granny and Grandad. Dad went out to the mainland to work. I would have been about twelve and a half, I'm not too sure, and I'd have all the kids laughing. If I cried, my grandfather used to call me in their

room and make me stand on the edge of their double bed and tell me to start crying. I'd start laughing. The same when I was laughing, he'd tell me to laugh but I would burst out crying.

Now when I think of those days, I believe they learnt to love me, even though Dad Cedie was not my real father. I love and miss them all too. God bless them.

Later Dad was working in a little town called Atherton, up in the tablelands in Queensland. My mum took us up there on a train. Later, as we started to settle in, Mum and Dad sent us to school. Brian got a job in the railways as a porter. I think a lot of young boys from Palm Island were sent out to different jobs. Brian would have been seventeen, and very handsome.

School was OK. I had a good mate there, named Ruth. I had some good times there. We used to have plenty of fruit in our yard and we used to go to the pictures a lot, even when we had no money. The owner let us book up till Dad got paid. I think that was when my dad started to drink a lot. One of my cousins came up to stay with us for a while, his name was Kevin Stafford. He was a good dancer. He taught me how to do the twist and we were always dancing. There was a twist competition down in Mareeba, and Dad and Mum took us down so that Kevin and I could compete. Kevin and I won twenty-one shillings for the first prize. I gave it to my dad so he could buy a drink.

Later on Mum, Dad and us kids left Atherton

and were soon living in Cairns with my Granny Nellie. Mum and Dad used to fight, and soon alcohol took over my family. It wasn't long before they split up. My dad later went back to Palm Island and my mum met someone else, and so I travelled back to Mareeba with her.

I would have been about fourteen when I met this Hungarian bloke. I used to live with my mother till I lost my virginity. I thought I was in love. Then I went crazy. I lost interest in school, everything. I had no one, nothing. I started to drink, work here and there but not for long. I was always on the move. I went back to Cairns and roamed around. I used to get locked up and go to court the next day, all grubby from the night before, drinking and sleeping in a stinkin' gaol. I never had nice clothes. I used to live with my friends, the Brown family, but mostly I stayed with my Aunty Stella and her family.

We were just simple people, my aunty looked after me good. Brian used to live in Brisbane most of the time, when he wasn't in gaol. He might have been known as a thief but he had principles and we loved each other, he was my brother. One time, I remember we was standing on the wharf in Cairns looking over towards Yarrabah, and I was crying and missing my mum and other sisters. He put his arms around me and said, 'Never mind, sis, we'll be alright one day.'

Brian would hit any man who would dare to hit me in front of him, he had guts. Once down at the Barrier Reef, which was a local pub for the

blacks, this fella put his arms around me and started crying. I didn't know at that time that he was my real father, Lee Stafford, I didn't find out till I was fourteen years old.

Later I went down to Townsville to live with my grandparents, Charles and Irene Palmer. We were very poor people, I had no income. I tried to go back to school in Townsville, and was told to stay at home because I had a lot of sores on my arm. I still don't know what from. Later on Mum came down to Townsville to pick me up, and I lived with her at Halifax. I soon got a job nursing at the Ingham Hospital, this is where I met the Kyle family and the Prior family.

I love looking after people when they are sick or old and helpless. I was good at it too. I remember once, a little boy died, he was just a baby, and that was my first cry as a nurse. His name was Robert. I got so upset with the doctor, I didn't believe he could just die like that, and I think I must have been praying and being a strong believer in God. I made such a fuss, the doctor had to do something. He started beating on his heart, and, thank God, he grew into a big strong man and his family have never forgotten. They still think the sun shines out of my ears.

I left Ingham, then I moved back to Townsville to live with my grandparents. My dad was working down in a little place called Ogmore in Queensland. So I decided to go and live with my father in Ogmore. When I was down there, I met a boy and I liked him. His name was Ronnie.

Ronnie's mum, Joyce, came from Palm Island, and his father was a South Sea Islander. They taught me how to sing and play the guitar. Ronnie's sisters, Derlene and Pat, were the best singers I have ever heard. My other sister, Opal, was living in Ogmore too, she would have been about ten.

We eventually left there to go and live in a little Aboriginal camp in Murray Upper. I lived there for a while with another boy. I just wandered around for a time. We had a hell of a life. I was like a nomad, I had no roots.

Me and my family were separated for a bit. I travelled with a country and western show. Larry was the big boss. I started to sing in public but I was shy and not really confident in my playing and singing. I ended up travelling with them up to Normanton, Burketown, then finally Mt Isa.

When I was on tour with the show, that's when I started hearing of Darwin in the Northern Territory. From there I went back to Townsville. I got to be good friends with one of my cousins, Alita. We used to knock around together all the time. At one time we would stay with my grandparents or at my Uncle Tibb's or Aunty May's. We never really had a home, and we never had any money and our families used to feed us. We used to always be starving. We met a friend who used to help us out a lot. He was known as the Brown Bomber, but his real name was Sid Santo. God bless him.

I used to get restless. I'd be either in

Townsville or Cairns. At one time my cousin and my aunties hitchhiked from Townsville. Another time we hitched a ride up to Cairns with this whitefella. He bought us some beers and we were having a good old sing-song, when suddenly this big bright light flashed across the car and lit up the whole sky in front of us. We all shit ourselves and we never said another word till we got to Cairns.

I can't really remember where I turned eighteen but I was glad to go to the pubs. Everyone used to get dressed up and go there, trying to get a drink. Then we'd all go down to the Old Common and have a good time, sometimes sad and bad.

Somehow I got to the Northern Territory and got a job in Katherine, babysitting and housekeeping. It was not the first time I'd had to support myself this way. I really had my heart set on going to Darwin.

After working for a few months, I decided to go and live in Darwin. While living in Katherine, I had got to be good friends with a girl from Western Australia, so we made plans to try and get a job up the top. We walked all over Darwin looking for work, and we finally found a job at the Royal Darwin Hospital, where we both were hired as domestics.

While living in Darwin I met this boy, if you could call a man of twenty that. We liked each other a lot and even thought of marriage, but as time went on I met another fella that I also liked,

so we just lived together for a little while. We both had good jobs, had a few good friends, plenty of money—we just had a good time in between the fights. I turned nineteen and even had a birthday party. My boyfriend bought me a watch, my first ever. He also got himself a camera so he could take some photos that night. He even shouted me to the beautician, they made me look really nice for once. The only problem we had that night was that my boyfriend forgot the flash for the camera but we carried on partying.

I worked for about five months before I got a letter from my mother, who was in a little town called Robinvale in Victoria. So me and my boyfriend caught a bus through Alice Springs, the Adelaide route. The trip was OK. We even went to visit the Pitchie Ritchie Sanctuary while in Alice. It was good to see my family again. My mother looked just as beautiful as ever and so did all my sisters. They used to live right on the banks of the Murray River. The only one who was missing was my eldest brother Brian. I think he would have been in gaol.

I started to get bored living with a man, so once again I had my freedom. The fella I lived with soon hitched a ride back to Darwin. I stayed in Victoria for a while, picking grapes and drinking the wine. There was another girl there who also came from Queensland and we got to be friends. Soon we got a job on the same farm and we shared the same hut.

My sisters, Vena, Opal and Gwen, were all

going to school, even though they lived in a tent. My mum sent them to school spotless. Even where we lived it was nice and clean. I later wanted to go back to nursing, so I wrote to this other boy in Darwin to send my fare to go back there. I used the money to go down to Melbourne, chasing my dreams of one day becoming a registered nurse. I got nowhere, as I lost hope because I never got that much education. I was nineteen and I even got lost in that big city, it was really cold too. I hated it. I lived with some Jewish people and they were really nosey. I'm sure they used to read all my letters that I got off my boyfriends, which used to be every day that I was living at that house. The postman used to always crack a joke about it.

Melbourne was a pretty large city. I later went on to live with some Australian family and they were OK. I don't like big cities at the best of times. I finally went back to Robinvale, and I met up with this girl again and we made plans to hitch back up to Townsville, then Innisfail. This would be the first time I'd ever hitched that far. I took one look at Sydney from the highway and all I saw was these great clumps of smoke and I hated the place already.

We passed through Wagga Wagga as they were having their Anzac Day march—it was sad. As we were leaving Sydney on our way to Broken Hill, the bloke we got a lift with nearly killed us with his reckless driving. We were shitting ourselves. Surfers Paradise was OK. I just

about spent all the money I had on souvenirs, which were pretty expensive. I never seen so many people on a beach. There were people of all shapes and sizes. We were glad to get out of the place. After plenty of laughs and starvation we soon got to our destination. By that time we were broke. We only had enough for some lollies, my friend said we had to exercise our jaw somehow.

Soon I was living in Townsville with my grandparents, and sometimes my Uncle Tibby and his family. My brother was still in gaol for receiving a lousy stolen dollar that he didn't even know was stolen. I went to the court-house the day he got sentenced for two years. I cried, broken-hearted. I never could understand why he deserved to be locked away for so long. Brian eventually came out of gaol, he also had made up his mind to marry his Yarrabah girl.

I met another fella, he owned a Holden station wagon, it was a nice car to drive. I took it down to Mackay for a drive the weekend Brian got married, so I missed his wedding. The trip down to Mackay was pretty wet. I picked up my sister Nerida and her boyfriend Darcy, and we all spent the weekend down there. I liked the town. Later I took the car back to the owner, he was a bit pissed off but he was OK later.

Later, my brother and his wife Mona came down to Townsville on their way to Brisbane. We stayed at one of our cousins' place for a couple of nights before we left. We were helping my cousin

Christine to clean her house. There was a girl there who used to live with another cousin, Tabby, she came from out west. As we were sweeping up, she was in one room and I was on the opposite side and there was a doorway in front of us. I'm not really sure who leaned the broom against the wall but suddenly the broom fell across the doorway. My brother was out on the verandah with everybody else who was there. They were all having a lot of fun. This girl told me that someone either in her side of the family, or my side of the family, was going to die. I laughed at her, as I didn't really believe in that sign, maybe because I didn't want anything like that to happen. We black people have our own beliefs.

We finally left Townsville on our way to Brisbane. We were soon stranded in Mackay, as there was a big flood there. That was the first time I ever been on welfare. We had no choice. There was also another family, from home at Yarrabah. We all slept under the same tree on the beach, just out of Mackay. That was the first time my brother clouted me over the ears, and boy did it ring. He hit me because I wanted to hit his wife. I never could control my anger, I had to hit someone or something.

I went to the hospital to try for a nursing job, which I got, so I stayed and worked for a while. Brian and Mona went back to Yarrabah. I loved my job. I felt independent. I made new friends and this is where I first learned to smoke

cigarettes, much to my sorrow. I got to be mates with this white girl and invited her to come up to Townsville, if she wanted. While in Mackay I met one of my old boyfriends, he was already living with another girl, who today is his wife.

I soon was going out with this fella's brother. He would have been a couple of years younger than me. He followed me to Townsville and later lived with me at my grandparents' place. We had no job and no income whatsoever. I soon got out of this situation. We were all living at this house, just all of us young people. My cousin Alita and I were pretty good friends at that stage—even though we had nothing, we were happy most of the time.

Somehow we managed to get by. My mother was still living down in Victoria and my grandmother, Nellie, was in Brisbane as she had to have one of her legs amputated, the reason being that she suffered from diabetes.

While I was nursing in Mackay, I had been saving up my money for a car when Brian and Mona came through on the bus. He rang me to see if they could borrow some money off me. I said he could, so he caught a taxi to the hospital. He shortened me the price of my car. I said to the taxi driver that that was the worst of having brothers, and we all laughed. That was the last time I ever saw my brother.

Brian used to always go and visit our Granny Nellie, who was down there. He used to take her out for the day. This particular time, he took her

up on top of a local hill in Brisbane. They were having a big feed of chicken and Brian told her that was the best chicken he ever tasted.

My brother was killed in a car accident about five months after he got married. It happened about 2.30 one Sunday morning. At the time, Mum was in Robinvale and I was in Townsville. He was killed instantly when his car hit a tree, and at the same time my mother saw him in some sort of dream or vision. He told my mum to look at what had happened to him. I believe the steering wheel had gone right through his chest. I was woken at the same hour by someone or something. Earlier on in that week, we were all playing a card game, which was a popular pastime of ours. While playing this game, I could not stop whistling. There was a girl staying with us who came from down south and she reckoned that it was bad luck to whistle at night. Again, I just laughed at these superstitious people.

Mum was going crazy because she knew in her heart that something was definitely wrong with either Brian or me. She kept telling my younger sisters that Brian was dead. My sisters freaked a bit, 'cause in a way they knew in their little hearts that my mum was seldom ever wrong. Oh, how I wished that she was wrong for once, my poor mother, how her heart must have broken.

It was the following Monday morning. Nerida and her boyfriend came over to Uncle Tibby's family home looking for me. As I said

before, we hardly ever had food, so we'd go over to my uncle's for a feed. They told me to help myself. While I was having breakfast, Nerida and Darcy come into the kitchen—I remember I was eating a tomato sandwich—when Nerida says, 'Go on Darcy, you tell her!' and he's telling her to tell me. So I scream, 'Tell me what?' So Nerida says, 'Did you hear about Brian?' She didn't even have to finish the story, I just ran from the table and into the lounge and started punching into the wall.

My dad was also there, he broke down. Darcy used to own a FJ Holden and he had it parked out on the street in front of the house we were in. I ran from the house and got into the car. The keys were in the car and I was about to turn the keys and was just going to drive the car straight into the fence, when Darcy reached me. I must have pulled nearly all my hair out, my heart had split in two. I cried for the next five months, every day and night. Brian was only twenty-four.

Somehow my mother managed to get his body sent up to Yarrabah. I tried to hitch a ride up to Yarrabah but I still missed his funeral. God, please forgive me.

The day Brian had come out of gaol, he went back to the gaol to take some smokes to his mates, so a couple of us girls went out for the ride. Brian got out of the car and was talking to these fellas. While there I said, to Alita, I think, 'See that man there? I'm gonna marry him.' When Brian got back into the car, I asked him who that man was

and he told me that was Lenny Illin. He looked bloody handsome and I wanted him all for mine. Call it what you like, but somehow I knew in my heart that one day I'd marry him.

I was still living in Townsville when Lenny came out of prison. I eventually met him. Somehow we ended up together one night. It would have been a month away from my twenty-first birthday. I didn't see Lenny again, as he wanted to go and see the rest of his family in Isa, so I felt restless and did not want to be in Townsville. I was so in love with this Lenny Illin, but what do you do when someone breezes through your life and then just leaves you alone?

There was this whitefella who was a friend of the family. He was going up to the Territory, so my Aunty Mary and I asked for a lift to Darwin or wherever. We made it as far as Katherine. We spent the night at a motel, then we hitched a ride up to Darwin the next day.

I met up with my mate Elaine, after not seeing her for about two years. She put me and Aunty Mary up. We walked the streets looking for a job and we finally got a job cleaning cars. The job was fun and the money wasn't too bad for the short time that we were there. I turned twenty-one up there but it was hard for me to enjoy myself, for my heart was in Townsville with Lenny.

Soon we had to leave Darwin because my grandfather, Charlie Palmer, had died. Grandad died in the arms of our dear friend Sid Santo. God

bless them always. My aunty and I had to hitch back to Townsville and I was really sick. Aunty Mary reckons that I was pregnant. I found out soon enough that I was pregnant with my first daughter, Shevanne.

We arrived in Townsville all dirty, tired and in sorrow. That night I slept on a double bed with my grandmother and Cedric, Aunty Mary's son—Ceddie on the other end of the bed, nearest to the wall. My grandfather told me once that when he died, he was going to haunt me—how true. After we had been asleep for a while, I could feel there was something else in the room. I tried desperately to open my eyes and a chill was going through my body. I was trying to touch my granny, was trying to call her, but nothing was coming out. My hands couldn't move till whatever was there had gone. I still believe today it was the spirit of my grandad, watching while we were asleep.

Later Lenny and I met up again. I told him I was pregnant and he seemed pretty pleased with himself, to think that he could make a baby in one night. Lenny started to take me out and soon I met all his family. I don't think they really accepted that I was pregnant with Lenny's baby, as I used to have a lot of other men in my life and I'd only been pregnant the once. It's funny, but I knew that it was his.

Lenny and I got on OK. I met his Aunty Flora and she invited us to stay at her place. Lenny got a job but sometimes it took him away from me.

As I was still carrying Shevanne, my sister Nerida, who was living in Townsville with a whitefella she had known for a while, kept an eye out for me while Lenny was away. I'd only see him on weekends.

While waiting for my baby to be born, I'd often go to bingo or play cards. The morning my waters broke, Nerida had just bipped the horn of the car to let me know that she was there. Both at the same time! We could not control our laughter. The house was spotless. All my clothes were packed and ready to go. I made Nerida drive slow, very slow, as I used to smoke like a chimney. I smoked myself silly. This was my first birth, it took about eight hours of screaming, grunting and praying—then no more pain, and never have I seen a more beautiful child. She reminded me of my Granny Nellie.

Lenny's Aunty Flora came up to visit and she was real surprised to see how much my baby looked like the Illins. Lenny came to see his baby, he looked really happy and proud. I had already picked her name out months before. I soon left the hospital but Shevanne had to stay in a few more days. You can imagine what my breasts felt like, full of milk. I felt a lot of pain.

Lenny and I started to fight a lot. While he was away at work, I started to gamble and Lenny started to drink too much rum. We just couldn't hit it. He was starting to put the shits up me and I wanted my freedom badly. I was starting to really hate doing what other people wanted. I

tried to find a way out of this relationship. I met this other fella, he was OK. I really cared for this man. I later went out of town to live with him. Shevanne was only a baby. Lenny came looking for me with a gun while we were in bed. He stood over us with this gun, so to save our souls I went back to living in misery. This was not the first time I'd had to run away from a gun. I still don't know if Lenny loved me or he was just being possessive, but he wasn't going to let me go without a fight. No matter how I tried or what I did, I felt lonely and miserable. You might as well say that I had a shotgun wedding.

The year that Cyclone Althea hit Townsville, I was pregnant with my next baby, Araluen. Shevanne was only five months old. Lenny and I got back together. Isn't it terrible when you can't have your own way? Not so much terrible, but it's heartbreaking. We still weren't happy. It was a case of having to live this way. Maybe I was a bit old-fashioned but I never knew that I could have survived without a father for my babies.

Araluen is still as beautiful today as the day she was born. I remember the day I took her around to one of Lenny's family's place, his uncle commented on how she looked a lot different from Shevanne but I couldn't give a damn. Lulu, as I called Araluen, was five months old when I got pregnant again. This time it was my first son, Leonard. Lenny decided that we should get married. I was two-minded. I definitely didn't want to get married. We ended

up getting a Justice of the Peace to marry us. Later we had a little barbecue with Lenny's family and just Nerida and her boyfriend.

We still had a lot of fights. What the hell do you do when you're struggling with three young babies and a husband that can not control his drinking and his temper? I tried to go back to nursing and I was also on Valium, 'cause my nerves were gone from the bashings I used to get. Broken ribs, broken spirit, and finally a broken marriage.

My dad was still living over at Palm Island. Lenny and I decided to go and take our kids over to see my dad. While there I had the chance to really let Lenny know how I felt. I stayed on the island while he went back to Townsville. This is when I met Ducky and I started to drink a lot too. I had Shevanne, Araluen and Leonard with me. My dad helped me to look after them.

One time, Araluen was getting coaxed away up into the bush by a ghost. I'd asked these other two girls that were staying there at the time, Monica and Marie, to double up with me and the kids, as I was really scared. I'd always heard of these things but I'd never seen anything like it. There was Monica and Marie, me, Araluen, Leonard and Shevanne, and we had all the lights on. We were even more scared when suddenly Lulu started to talk. She was saying to something we couldn't see that she was not allowed to go anywhere and that she couldn't even if she tried. I was holding her so tight. She was telling that

thing or whatever to come down to her. Dad and Aunty Margie, who lived with Dad, used to hear Lulu every night after midnight trying to open the door to go up into the hillside behind the house.

I soon left Palm and after that I went back to Townsville. Lenny took me back home but things were worse than ever. I made plans to run away from my husband, as far as possible. I had to leave my baby son. Lenny always told me I could take the girls but never his son. My mum gave me the fare to catch a plane to Brisbane. My poor little girls, they had to suffer for a little while. I sold my wedding ring for five dollars—to a cheapskate. Not that the ring was expensive or anything, but it makes you feel sick when you know that people take advantage of you. I went and enrolled in a barmaid course, which I passed. I don't think they hired too many black barmaids in those days. I soon seen a job advertised in the papers for some girls to learn massaging.

I had to get a babysitter. I did not know what sort of job I was getting into till I started work. If you can call it that. The money was good. I got a one-room apartment on the run-down side of town. I soon ran into Ducky. I did not know that I was pregnant with my fourth child when I left Lenny.

One day Ducky and I went on some sort of drinking spree—that's the only way I could describe this day. There were lots of people down in Brisbane who came from Cherbourg or

Woorabinda, who used to drink at the pubs. This particular pub was called the Ship Inn. I was so jealous of Ducky that I almost wanted to kill him. I got into a fight with Ducky over a couple of girls. I broke a loose bottle of wine and was just going to stab him in his throat when this lady, who was an old friend of my mum's, came up behind me and held me by the wrists to stop me. I ran over to a wall that was made of cane, and punched it with all my might with the broken bottle in my hand.

I still wasn't satisfied. I offered a couple of these Cherbourg girls a fight and a fight I got. The finger on my right hand got a deep cut. There was blood everywhere. Ducky finally got me to stop and go up to the hospital to get stitches, and then we went home. My fingers started to swell, one at a time, till the whole of my arm was swollen. I never felt so much pain. Shevanne and Lulu had to look after me. If Ducky had not come to see me that weekend and taken me to the Mater Hospital, I would have died. The girls went into a home where they looked after children whose mothers were in hospital.

When we got to the hospital, I collapsed. I did not awaken till I came out of theatre. I found my little finger pitch-black. I cried for days. I was twenty-four years old, had three young babies, one on the way, and was about to lose either my finger, my whole arm, or my life. The doctors and the nursing staff saved my life. After about a month of drips and morphine, they finally let me

out of hospital. I used to look forward to getting my needle. I did not know that I was getting 'addicted. The doctor soon changed that situation. I came out of hospital and found another place to live—thanks most of all to God. I also met this girl and her mother at the hospital and they used to write letters to my family for me.

I got a flat over in another arsehole part of Brisbane. Got my girls back from the home. They were real fat and healthy and it felt good to have them back but I missed my baby boy. There were some Queensland boys staying on the other side of the flat where we stayed. We all went up to the pub and I left Lulu in the car. It was an automatic and it was parked on a sort of a hill. Me and Ducky were standing out in front of the footpath watching Lulu in the car. I don't know but I must have turned my back for a minute, when Ducky said that the car was rolling. It was one of the busiest streets in Brisbane. God only knows how my little girl never got killed by the oncoming traffic. Well, I just stood there shaking. All those fellas started running after the car. They caught up with the car and got Lulu out. One of the boys gave her the biggest hiding of her life at that time.

I was always having some sort of bad luck with her when Lenny and I first went to Yarrabah. While we were together, we went out to Back Beach. There's a sort of lagoon there. Lulu and Shevanne were swimming in this little bit of water. Nerida and I were sitting not far from

them, watching them. I was pregnant with Leonard. We seen Lulu dive in and the next minute she floated to the surface. Well, I could not move at all, I was in shock. Nerida ran down to them and pulled her out of the water in time— thank you, Lord, again.

After a while, Ducky went back to Palm Island. I later followed. My mother was living there at the time. I couldn't go back to Lenny as we had nothing to go back to. I never had much future with Ducky either. I believe that a person has not got much of a future with anybody that's married and I was married, much to my sorrow.

I had my baby on Palm Island. Mum came with me in the labour ward, as I was scared. The little room really scared me. While I was having my baby, my mother was there to hold my hand. Mum even went green when my baby's head showed. I had a girl. I named her Anna, after Mum, and Elizabeth after one of my best friends, Elizabeth Geia. Ducky came to the hospital to see us. Anna was white and she also had the reddest hair. He cried when he realised she did not belong to him, he also punched me in the face.

My baby's father was Lenny but he never admitted it to anyone, not even to himself. When I left the hospital I felt alone and unwanted. Later Ducky grew to love Anna, he even gave her his name. We started to fight a lot. This man was not any better than any of the rest, but he loved my baby. I never seen a little girl with so many clothes.

After getting speared in the ankle with a steel fence post and almost ending up a cripple, and fighting with other women for this man, I left the island. I took my kids to live in Townsville. Ducky was OK for a little while. I ended up in the hospital again, this time to have an operation on my third finger. I had lost the movement since I lost my little finger.

The day I went into theatre, the doctors gave me anaesthetic. Then they gave me another needle in my right collarbone. Later I awoke in the theatre and what I saw freaked me right out. The doctors were opening the cut in my hand and I could see right into my body. I can't really explain it but it was as if I was looking into my soul. I ended up with fifty-seven stitches. I couldn't stop crying. The doctors and nurses were very kind. I went home after a few days and had to keep my hand held up in the air.

Ducky rigged something up that night. I remember we were both reading and I must have fallen asleep. The next thing I knew, I was up near the ceiling looking down. I could see myself down on the bed and I was struggling to hold onto Ducky's leg, to keep from floating away. I got better after a while. My hand was and still is as ugly as ever. Thank God I can still do a lot of things with it.

Ducky used to own a Valiant. One day I ran away with it to Yarrabah. I had not been there for a long time. This is where I first met Lindsay. I met a lot of others too but I really wanted this man. Ducky came up to get his car and me. After

he reported me to the police, I went back to Townsville with him. There was really nothing left between us, but people think sometimes it's the end of the world when they lose out to another man or woman.

Lindsay was getting ready to marry his girlfriend of a long time, who was also the mother of his two daughters. I went back to Ducky, God only knows why. He even asked me to get engaged and to file for divorce from Lenny. I left Ducky again, I could not stay away from Yarrabah. One of the times I went back to Ducky, I fell pregnant with my second son, Lee.

I was over on Palm Island the day Lindsay and Vicky got married, that was the saddest day of my life. I stayed on Palm for a little while, I even got a job typing, as a clerk of courts. The job was OK but my heart was in Yarrabah.

I went back up to Yarrabah to live with one of my sisters, Vena. Lindsay's wife and I used to fight just about every day of the week. I stayed away from Lindsay as I wasn't sure that Lee was his baby, and besides, he was newly married.

I used to gamble a lot while I was pregnant. I bought an old Falcon with my winnings. I could not even fit behind the wheel as I was that pregnant. Lee was born in Cairns. I took him down to see his so-called father. He was too busy with a new girlfriend to bother with my baby, he told me to take him back to Lindsay.

After a while, my mum came back up to Yarrabah to live. By this time she'd met up with Stanley Connolly again, after all those years, and they became good friends. I still believe today

that Uncle Stanley wanted to make up to Mum for his son, my brother Brian, who he never really knew.

As time went on, the council gave me a little cottage to rent. Shevanne and Lulu were living in Townsville with their Uncle Desi and his wife Donna. I'd had a hell of a life but my poor kids suffered more than me. Kids are good people. They love and stick by you, no matter what. Grown-ups only think of themselves. Leonard was still in Mt Isa, living with his Uncle Bobby and his wife, so I only had Anna and Lee living with me.

But I was still in love with a married man. I should have learnt that you cannot have other people's husbands. I got pregnant with my third son, Lindsay junior, and during my pregnancy I had a really violent argument with Lindsay. I really suffered after that, I went into my own little world. I would not talk to anyone. They reckon women while they're pregnant sort of lose control. I was like a zombie, I had no interest in anything. I thank God for my lovely mother who helped me through this sorrow I had.

Lindsay got his wife Vicky back. What would men who go astray do without their loving wives? Of course when my son was born, Lindsay was proud. He always wanted a son. I reckon Lindsay loved both his wife and I, and his daughters and son. We did not deliberately try to hurt Vicky, God knows I am truly sorry. Lindsay was a good man in his own way and it was hard not to love him.

During this time, I got my Shevanne and Lulu

207

back from Townsville. I went to visit them and their little hearts ached to come back home with me. Shevanne came over to my aunt's place where I was and begged me to come home. So what could I do? Lenny was hurt that the kids weren't happy with his family and he told them never to talk to him again. So I took them home with me, back to Yarrabah. Eventually, the council agreed to give me a house. So I had Shevanne, Araluen, Lee and Lindsay Junior, who everyone called Bert. Mum had Anna.

I was still drinking and going through a hard time. One day I had a big fight with Lindsay's family. I was bad and yet I had a good heart. I regret fighting with them. It's just that I wanted Lindsay so much. I knew that I could never have him, but something caused me to think that one day he would be mine.

While I was drinking and carrying on like there was nothing left on earth to think about, my kids were suffering. Lindsay came to the house again, we fought. I chased him with a knife so he whacked me in the legs with a stick. I put up with all this shit for four years. Later I got a flat down beside the beach. Later still I got pregnant with Shane, my fourth son, named after Lindsay's brother Shane. Again, I went through a lot of heartache.

By this time, I believe Lindsay was starting to realise how much he was hurting me and Vicky, so he really started to change. They went to church to try again. So once more, I had to suffer in my own little world. After Shane was born, I

finally got my tubes tied. The heartaches were still there. I was really hurt.

I was really crazy with hurt. So finally I had to get help. I decided to go to church and let God help me. I believe that He finally got me to realise that I had been lost. Later on I moved out of Yarrabah and went to live in Townsville. Now that I look back, I would have gone completely crazy if I had stayed in Yarrabah any longer. I was thirty-four years old. I had Lulu, Lee, Bert and Shane. Mum looked after Anna and Shevanne.

All the hurt finally started to fade. Life started to look really good, me and the kids were happy. Thank God for my Araluen, who helped me raise her little brothers. I got my cousins Janie and Mavis to come and stay with me. We partied, we had a guitar, plenty of food. The kids were happy and the rent was cheap. We just had a good time, then Ducky came back into the picture and everything went sour. Eventually Lulu went to live with Mum, so I left the flat and went back to Yarrabah. I stayed long enough to get my money and I asked my cousin to watch Lee. Bert stayed with Vicky and Lindsay. Shane and I got on the next bus to Darwin. We had barely enough money to eat. Later my mother picked Lee up and looked after him.

Today I live in Cairns, North Queensland. All my children are grown, my baby boy Shane just

turned sixteen years old. I feel like those years are long gone and the times have changed. I now have six grandchildren and one on the way. I live alone but my kids and grannies come and visit me when they're in town, or I go to Yarrabah to see them.

I've lived in Port Hedland also. I've hitched to and from Port Hedland, I had money to travel but I wasn't going without my faithful dog Luke. He was a kelpie. Luke has died now, I had him for ten years. I've lived in Cooktown too, which is a beautiful place.

I met Ernie Dingo when he came up north, he's a lovely man. They have a dance/cultural festival in Laura and I asked him if I would be able to sing up there and he let me, as he was sort of hosting the show. It's the first time I have sung in front of a couple of thousand people.

Bert and Shane's father and his wife looked after them for about eleven years. I thank them very much, as I couldn't handle the way I used to live when I was a drunken woman. My poor children put up with a lot, but I thank God they forgave me and still love me as much as I love them. Today, Lenny writes poems and does paintings. Lulu has a son. Anna has identical twin girls and a son. Shevanne has two daughters. They are my pride and joy. I reckon I'm a better grandmother than I was a mother. I thank my mum and all the people that have helped me through the years with my children. One day I'll make it up to them for all the hurt I've done.

KATHY RICHARDS

Nobody's Child

KATHY RICHARDS

Nobody's Child

I want to tell you my story. It is the story of a child taken from her family at the age of four. I was taken into the care of the then Department of Youth and Community Services, now Department of Community Services. I was to remain in their care for fourteen years. Ten of these years were with a foster family, the remaining four in nine different homes. My real family got scattered all over the place and I am only just getting to know some of them now. We have all been affected in different ways, because of the different things that happened to us along the way. We were all hurt, some more than others, but we are all doing what we can to live our lives as best we can.

At times, I don't understand my real mother at all. Sometimes I get angry when I think about it. Also I don't want to see the department return to the days of moving kids around all over the place. That's one reason for telling my story. The other is to say, despite all that has happened, I have survived. Today I live with my three children, whom I am raising alone. I think I'm

doing a reasonable job. Even though it's very hard bringing them up on my own, I could never give them up to solve my problems. I work, have friends and am trying to rebuild relationships with both my real and foster families. Over the years the department has asked me to speak to people wanting to foster kids, to tell them what it is like for the kids. Though it makes me very nervous, I am glad to help.

I want to say to other kids with a past like mine, get on with your life! Don't blame your past for choices you are making now. To those who were unkind along the way, I hope you recognise yourselves and feel uncomfortable. To those who helped and were kind, thank you.

My mother was an Aboriginal, my father a pom. They hadn't been getting on for a long time, but that hadn't stopped them having kids. My father kept shooting through, leaving my mother without support for us kids. He was taken before the Children's Court on a charge of desertion. He agreed to move back in with my mother and care for us kids, but it didn't last very long and he soon shot through again. So my mother told the department we had nowhere to live—a lie, because my relatives would have looked after us. She was still seeing my father, but she didn't tell them that.

I was four years old when I was placed, along with my two older sisters, an older brother and

two younger brothers, in an orphanage. My youngest brother was only a few months old at the time. We were told we would all one day be returned to our parents. In fact, only my older brother and one sister were returned. The rest of us got scattered everywhere, scattering our minds at the same time. I don't remember anything from those days, I was too little, the situation too confusing. My older brothers and sisters remember bad times. I'm glad I don't. Maybe that's why I have less anger than them. But I don't understand why my mother kept having kids when she couldn't cope with us. She had three more after we left, that makes me feel like an unwanted pet. You get rid of them and then get another one.

My mother says she tried to get us back. But I have recently read my file and discovered she didn't. In fact it looks like she planned to dump us. My father wasn't living with us at the time, but he moved back in with Mum two days after we left. The welfare told Mum there were certain things that would help to get us back. She was told to apply for a house from the Department of Housing; she never did. She was told to write to us to help maintain the family links; she never did. She only wanted contact with the two eldest children, her excuse was that the rest of us were too young.

She even claimed that the next child born, my younger brother, was illegitimate, so she could collect from Social Security. As my father had already moved back in, there is no doubt about

my brother's legitimacy. It was just another lie.

My natural mother is a funny lady. I don't know how to explain my feelings about her. You bring a child into the world, you have to be so careful. Their first few years are so crucial as to how they learn about life. You teach them to talk, walk and know right from wrong. But most of all you teach them about security. If they don't have security as a child they will take that feeling of insecurity into adulthood, as I have. To learn that your parents don't want you is a hard thing to take. It is even harder when you discover they replaced you with three more.

She had family who would take us, her relatives had decided who would go to who. But she waited until her sister had gone to work, she rang the welfare and told them her brother-in-law had thrown us all out. The welfare came and took us all on a train to Gosford. She then got on another train to Sydney, to tell our father what she had done. Nobody in the family had heard from my mother for about two weeks after we had gone. What a burden we must have been! My older sister recalls all of us being locked in the garage, with my father inside plastered as we banged on the door trying to get out. We lived in this garage. She remembers another time when Dad brought home his girlfriend to meet us. That ended up with Mum and Dad in a brawl and us kids trying to separate them.

My older sister says our father interfered with her as a child. She's blocked a lot of it out, but she is sure it happened more than once. She tells

me of all the fights that used to go on in our house, with my dad drunk. We kids were usually left to our own devices, playing in the streets and around old factories and garages.

My sister also remembers when our family was split up. We were all lined up in front of the judge, and I had to tell him what our names were. Then, as our mother screamed on the side of the road in Nan's arms, we were bundled into a car with a strange man and woman and driven away. A train and another car ride and we found ourselves in a large laundry room with big stone tubs. Some woman was giving the baby a bath while the rest of us stood there watching. My sister got into trouble for crying for our mum. The next thing we knew we were all separated.

My older sister didn't start school until she went to her foster parents at the age of six, nearly seven. Our teeth were yellow from filth and we had no clothes. Mum didn't even remember if I had had my immunisations. So for years I was off to the doctor, getting my needles. Having placed us, my natural mother refused to sign adoption papers. Always telling the department she would one day have us back. The day never came.

I went to a family in the west of Sydney. They had been waiting for a long time to foster a child. The officer from the department who assessed their application said they were decent parents

who had a good relationship with their children. I remember feeling special because they showed me off to everyone, saying I was their daughter. I don't remember missing my family. I was happy. I settled in alright. I had an older sister, a brother the same age as myself, and a younger brother. Not long afterwards, another baby came along, it was another brother. I guess the family was complete then.

The district officer who visited to see how I was settling in said I was 'Excellent, talkative and can be rough and demanding if she feels you are not paying her enough attention.' And again: 'Kathleen's beautiful looks belie her extroverted, open nature. She is a very affectionate little girl who tried to compete with her older brother and sister.' And finally: 'Very pleasant affectionate little girl and the foster parents are very pleased with her.'

I went to school and felt like everyone knew I was adopted. I made friends like any normal school kid, but still felt different. As I got older, I felt I was behaving like a normal teenager. At least I wasn't doing anything my friends weren't doing. High school was great. I felt independent and thought I knew everything. I was an outgoing sort of a person and was with the best group in the school (definitely not the goodies). School dances, jigging school, boys and dope were the order of the day. I had my first taste of dope at a friend's house and all I could do was laugh.

I used to play competition netball with my

sister for the local club. I loved it. I was getting fat and I suppose it was to help me get fit. My sister and I also did physical culture, where you act like a graceful lady. That was fun too, and we won a few medals and trophies between us.

I started to lose interest in these sort of things when, at the age of about twelve, the welfare approached me with the news that my real sister wanted to see me. I had never really thought about this before. Sure, my real family were on my mind, but I couldn't put faces to them, because I was so young when I left them. My life had changed so much. I was confused, and looking back I would say frightened, but I wanted to meet her. It was all arranged and we met at the local welfare office. We both cried and it was good to have a piece of my past. She had already seen our natural mother. After that meeting things began to change at home, my moods changed. I didn't notice it at the time, not until it was too late.

My sister and I got to know each other by going to each other's houses on the weekends. Her foster parents lived in a two-storey house in Blacktown and I thought they were really rich. It was nice to think that anyway. Her parents were both school teachers, so she ended up in a really nice family (no jigging school for her, I bet). Little did I know this simple contact with my real family would bring so much trouble into my life. Things were never going to be the same again.

All through the years my foster parents had made repeated applications to adopt me. My

mother had always refused, saying she intended to have me back. It is obvious reading my file now that nobody believed she ever would. I was confused, I loved my foster family and really wanted to belong. But meeting my natural sister reminded me I had another family. My district officer, when explaining about the adoption, told me it meant I would never see my natural family again. I was not prepared to take that step. My refusal to be adopted was interpreted by my foster family, unbeknownst to me, as a rejection of them. Nobody ever sat me down, explained it all properly to me, or asked me what the problem was. How I wish now they had.

A few months later the welfare came again. This time my natural mother wanted to see me. I was scared, I was nervous, but my foster parents seemed to be all for it. I found out years later that they were the ones really scared about the situation. I also found out later my mother only asked to see me because my sister insisted. I wish I had known that then.

It was all arranged for a Tuesday. I was all of thirteen and not sure what to expect. My foster mother and I walked into the same welfare office where I had met my sister, and there she was. My real mother, with my nan and a little brother. We just stood there and hugged and cried for what seemed forever. I was happy to see her, but I had a lot of questions for this woman who now

wanted to play my mum again.

I started spending time at her place on the weekends, to get to know my family again. Here I was allowed to do things I wasn't allowed to do at home. I didn't realise at the time that that was only because my real mum couldn't give a shit. For example, I could smoke. It was different not to be smacked because I had smoke on my clothes or my breath. I used to throw things like that into my foster mother's face every time we argued. I didn't stop to think that her rules were a sign of her caring. Reading my file again recently, I noticed that all my district officer's reports before I met my real mum again described me as being 'a delightful, attractive, slightly over-weight little girl, with a ready smile.' The descriptions began to be less flattering from this time on.

At this stage, things were becoming unbearable at home. When I look back at it now, I realise I pushed them to do a lot of things. I started jigging school a lot, and going to friends' houses, instead of going straight home from school as I had been told. Because my foster mother was working part-time now, at the local shopping centre, I guess she wanted to know where we kids were. Of course I went against this demand. I wasn't going to be told what to do, my real mother would not have made such a rule.

The adoption issue came to a head—now that I had met my natural mother again, there was no way I was going to risk losing contact. My opposition became more pronounced. In the face

of this, deeply hurt, my foster parents dropped the action. Aware I was no longer 'their little girl' my behaviour got worse.

I ended up running away on my foster mother's birthday, but they found me and brought me home. My mum sat on my bed with me and cried, asking me, 'Aren't you my daughter?' That made me feel guilty and happy at the same time. I don't remember her saying that she loved me. I felt like I was being punished more than my brothers and sisters, for the same crimes. When I tried to be good, it didn't seem to make a lot of difference. I loved and still love my foster parents and brothers and sisters dearly. I am not sure how they feel about me. I am not very close to my foster sister now, I think she blames me for what I did to Mum and Dad. When we were kids we slept in the same room and held hands between the beds to go to sleep at night. I know I hurt them, but that wasn't me.

The department now knows the mistake they made, splitting my family up and then reintroducing us without adequate planning. I am sure there are people out there just like me, who have family all over the place. My jigsaw still isn't complete. I still have one more brother, Danny, to meet, but that won't make up for what I lost. Danny is three years younger than me. When they split us up, he was just a young baby, and he was fostered by a family in Wollongong. I later tried to contact him and was told by the foster parents to leave him alone. No other attempt has been made, I'm not sure if he knows of my existence.

During this time, my foster parents asked the welfare for a break. Or perhaps the welfare suggested it, I'm not sure. Anyway, I was placed into Minali Receiving Centre for a short time. I'm not sure what it was supposed to achieve but I enjoyed it there. I made some friends, who would get me into more trouble later on. After a while I returned home, but I had learnt some new tricks and things did not improve. Nobody had told me that foster parents could run out of patience.

On the second-last school day of the year, my name was called out over the PA system to come to the principal's office. What had I done, I wondered, as I walked up there. There was Mr Scholl, my district officer, standing there like a cat who had just eaten a mouse. He was a tall sort of bloke, with a beard, and very solid. He talked to people like they weren't anything in this world. He thought he was the greatest. I wasn't the only one who felt this way about him, nobody in the whole school, teachers included, liked him.

He said, 'Come on, get your things, your foster parents don't want you anymore.' His smile hadn't faded while he said it. I was stunned and hurt, I had no idea this was coming. He drove me home and supervised while I hurried into the house, without a word for my mother. She too remained silent, a long look passed between us. I got my things together as quickly as possible and

225

walked out. I was locked in the car while Scholl had a talk to my mother and then was driven away. Ten years with this family and it ended like this. I had no idea my foster parents felt so strongly that they couldn't handle me. Although I had been warned, I didn't believe they were serious, if I'd have known they were I would have tried to improve my behaviour.

I was hurt, but I thought there was nothing I could do, in any case, no one asked me what I felt about it. What would happen now? I had no idea. Perhaps my real mother will come and get me, I thought to myself. Maybe that was why she had been in contact lately. But that hope didn't last long, my real family didn't even contact me, let alone come and get me. They let me down, again.

Truth was, nobody wanted me. I was nobody's child. I was too old to go to another foster family, not that I would have anyway. So I was put in a home, the first of many to come. It was trouble from here on in.

One day I rang my foster mum and asked if I could come home. The house-father, knowing what the answer would be, comforted me afterwards with a cigarette I wasn't supposed to have. That didn't stop me from leading an escape party one day, though. We said we were going to visit a friend who'd absconded. The police picked us up not far from the hostel. But

thanks to the house-father, I didn't get into too much trouble.

My walls started to come down. When I had to leave there to go to a working girl's hostel, I cried a lot. I would never meet someone who treated me like a daughter again, or so I thought.

The home I was taken to was called Brougham. I hated it. I got in with a group of girls and we took off from the home. Actually we went to the home I had been in for a short time, Minali. I wanted my new friends to meet the friends I had met there. Funny, ay? Running from one home to another! Our minders didn't think so, from that time on we were followed everywhere we went.

I was allowed to visit my real parents for Christmas, but because my dad was there, I didn't want to go. They found me hiding under the bed at the home. I came back early, saying I didn't like how they lived. My dad would get drunk all the time and bash my mum. The house was filthy, things were always a mess. Even Brougham looked good by comparison.

We used to go for walks on the beach. Someone would be right there on our heels, making sure we didn't get up to anything. One day we lost the youth workers on purpose and that's when the cops were called. They put us in a lock-up girl's home called Glebe Shelter, it had bars on the windows and lots of rattling keys. I just seemed to be getting into trouble wherever I went.

I don't think I deserved to be there. There was

a girl called Judy who had a girlfriend, Donna. I had heard about that sort of thing going on in girls' homes, but I had never come across it before. She tried to put the word on me, asked me to come into the pantry with her to get something. I wasn't having any of that, so I told her she could manage it by herself. When she turned eighteen she was sent to gaol. I don't know what she had done, I never saw her again. Meanwhile, I made friends with some of the other girls, who were really nice. I don't think they deserved to be there either.

When Judy left, Donna tried to take over and run things. We didn't like that very much. So one night, when she was tucked all cosy into bed, seven of us walked into the bathroom, one at a time, got a mouthful of water and all together spat it at her. She ran to the door, screaming until the matron came and then she told them what we had done. The matron didn't care and just told her to go back to bed. We won and she wasn't smart to us after that. I was learning how to survive in the system, though not necessarily in the world.

Finally, three of us got sent to Minali, the place I had always wished I was at. I really liked it there, you were treated decently. It's a place where you stay while they work out what is best for you. A sort of holding place. The house-father took me under his wing and showed me that someone could really care about me. However, my file records a change in me since I had been there last. I wasn't as happy and was

more difficult to control.

At this stage I was losing friends like you wouldn't believe. They were all going to different places, I didn't like this at all. I was beginning to go back inside my shell quite a bit. It took me weeks at this new place to feel comfortable with anyone.

I did finally make friends there with a girl called Sharon. We would go out on Thursday nights to the pub, even though we were only fifteen, drink ourselves stupid and go home and sleep it off. We were walking up the main road one day when a guy in a panel van stopped and asked us if we wanted a lift. We got in and just drove around for a while. He was nice, I ended up going out with him. He was my first sexual experience.

I was a virgin, but this hadn't stopped Glebe Shelter doing an internal examination with a speculum. They didn't believe me, I guess. It hurt a lot and I remember bleeding a little bit, the doctor said it was normal. Anyway, with Ray it was my first time, it didn't hurt and it was great. I loved this guy so much. Eventually we broke up and he ended up years later marrying another girl who had been at the hostel. Good luck to them. As for me, I swore I would never love again.

Meanwhile, we had heard about some car-sick tablets that get you high. We decided this was worth a try. We bought one brand and popped about four each, but nothing happened. So then we tried the proper ones, and boy did they get me high. When it first started coming on

229

I couldn't get my breath. I raced back to the hostel and tried to get water down my throat. I was in such a panic. When I finally got my breath, I swore I would never use them again. We did.

The lady at the hostel was so stupid, she didn't know half the things we got up to. When I first got there we had house-parents, but they went on a holiday to America and never came back. Apparently, they were into some heavy stuff and got into a lot of trouble, but we were never told what it was all about. This lady, who used to only be part-time, now had to come in full-time, and we didn't like it. We used to sneak out at night-time, get drunk and sneak home before she was any the wiser. And we could really suck her in. One night we got into bed and started rattling the venetian blinds. She came running in, frightened that we had busted once and for all. Helen and I pissed ourselves laughing, she looked like such a fool.

Helen was my best friend at this time, she was nice. She too had come from a broken-down foster family. Through our joint efforts the lady ended up having a nervous breakdown. The hostel got closed up and we got transferred to another one.

I was starting to enjoy myself, even though I was trying to get back home to my foster parents. I still had contact with them and now I could go home once a month. It wasn't the same as living

there, but it did give me a chance to see my school friends. Two who stuck by me all the way were Cheryl and my foster cousin, Debbie. They used to come and see me in a few of the homes and I would ring them whenever we could use the phone. Talking to them made me want to come home, too.

This hostel was different from the last one, in that it didn't look like a normal house in the street. It was in Strathfield. It was really big, with two storeys and two dormitories. One was a big room, the other was smaller. Helen and I were warned that if there was any trouble there, they wouldn't put up with it. Who us, start trouble? I was about to turn sixteen and trouble was my middle name!

A new girl came up from Mittagong. She didn't know the big smoke at all, so Helen and I took her into town one night and left her there by herself. When we arrived home without her, the house-father asked us where she was. 'We don't know, she lost us!' About an hour later, she rang up in a real state, telling the house-father we had racked off from her and she didn't know how to get home. We were grounded.

What we used to do if we got grounded was to be perfect angels during the week. They would forget all about what had happened and we would be allowed out the next weekend. Worked every time. Until the girl from Mittagong got even. She awoke one night screaming, saying she had found a knife under her bed. She said Helen and I put it there. Unless Helen wasn't telling me

something, neither of us knew anything about it. But of course, no one believed us. The house-mother told the welfare I was capable of murder. I knew I had a look that could kill, but that was going a bit too far.

The girl from Mittagong really bunged it on. Every time I came near her she started screaming. They even put her on Serapax. I guess she was serious about wanting to get rid of me. The house-mother was only too happy to believe her, I think she might have been scared of me too.

Helen and I were both shifted to the flat out the back that was normally used to get girls ready for the outside world. That wasn't what they had planned for us. We were to go to work and come straight home. Our tea would be delivered to us every night and we weren't allowed out on weekends. This wasn't fun anymore, but at least I still had Helen. About two weeks later, they said Helen could move back inside and be one of the family again, but not me. They had had a meeting and all the girls said they were shit-scared of me. They didn't want me back.

In the time spent by myself, I turned to writing poetry. Then I got transferred to a hostel at Arncliffe. Apparently they really had to do some talking to get them to take this violent young thug!

The new hostel was a church one. Were they trying to tell me something? Every Sunday

morning, without fail, we would all get in the bus and go and say hi to the Lord. Then we had to mingle afterwards. I guess I have to admit we did meet some nice people there. Like Richard and Sue, a lovely couple who lived close to the church and invited me over all the time. Richard made me a beautiful handbag out of leather that I still have today. I don't use it, but I keep it to remind me of them.

That part of the church stuff was OK as far as it went, but I really did object to being dragged along to the Billy Graham Crusade. A couple of the girls went forward to become born-again Christians. I believe in God but I don't believe you have to go to church all the time to prove it. But that was what this place was all about, church.

We had a great matron, Sue was her name. She was kind but wouldn't take any crap. Julia, the deputy matron, was a crazy lady who made us laugh. It wasn't a bad time there, but I was still pretty confused. At this time I had contact with both my natural family and my foster family. I still wanted to go home to my foster family, but it didn't seem to be possible. One night I went out as usual, but didn't come home. I don't remember now what I did, but apparently I just strolled in the next morning as if nothing was wrong. It was about this time we all agreed I should move on.

The welfare gave me the money and I moved out with another girl from the hostel, into a flat. This was great, we could do what we wanted,

with whomever we wanted, whenever we wanted. We used to have the welfare check on us all the time, so we would make sure the place was free of beer bottles and all that sort of stuff. My district officer was young and really understood a lot about me. She said if ever I needed her, not to be too frightened to ring. Because I was a state ward it seemed to me that the welfare were at my beck and call. If I needed money for things I would go to them and get it. They spoilt me a lot.

We ended up moving to a nicer place, with a guy I had fallen in love with. He was sleeping with my flatmate and also had another girlfriend. I couldn't stand it after a while and asked to return to the hostel.

I was fairly shy by this stage and didn't want to let anyone get close to me. I think that's why I made a lot of grown-up enemies. I had lost so many friends as a result of all my moves, I was frightened to make new friends in case I lost them too. So people wrongly got the impression I was a toughie, when inside I'm not tough at all. I just want someone to hang around, so I can show them who I really am. I need to be loved to show love, that's normal.

We had a new matron now, Robyn. She was a fairly short person, funny and sometimes real angry. I met Carol and we sort of looked like each other, so we said we were sisters whenever we went out. We took off from the hostel one night, I don't know why, and met a taxi driver who took us home to his place. He had a wife and a little

baby. It was so unusual to be with this normal family. The wife welcomed us and said we could stay there as long as we wanted.

We rang Robyn and she told us to come home. We made her promise the cops would not be there. Eventually she convinced us, and we returned home. Our punishment was to be grounded for a week or two.

After the grounding we returned to our usual activities. We used to go to a disco in town called Adam's Apple. This would be our hangout on weekends. One night we met a group of guys. They drove us to a park at the back of the hostel. One of the guys really liked me and I guess I liked him too. We were all pretty pissed. He was swinging me on this chain thing and he wouldn't stop when I asked, so I jumped off. I landed awkwardly on my high heels and sprained my ankle. I couldn't walk, so they took me to hospital and rang Robyn on the way. She said she would meet us there.

She sat in casualty with me for hours and didn't even comment on the smell of alcohol on my breath. I had to go back to the hospital the next day and again Robyn accompanied me without a word of reproach. I guess she figured I'd been punished enough. I had to get around on crutches for a while, so that limited my activities briefly.

I ended up going out with the guy from that night. Paul was Italian and really was in love with me. He sent me letters and cards for no reason at all and spent all his time with me. I fell pregnant

to him, but by the time I found out we had split up and he was going with someone else. I don't really know what went wrong, except maybe I couldn't cope with someone loving me. It became a pattern I was to repeat. Anyway, there I was, seventeen and pregnant, Paul threatening to kick me in the stomach.

Robyn helped me with decisions and I chose to have an abortion. I was in no shape to have a baby at that stage. The boss bloke of the hostel was a reverend or something and would have kicked me out if he had known about the abortion. So Robyn didn't tell him. Paul was waiting for me outside work the day before the abortion. He asked me if I was pregnant and I said I wasn't, well I wouldn't be the following day. We left it at that.

The following day Robyn came with me, even though it was her day off. But she wasn't allowed in the room with me. They had a chat with me first, to make sure I was doing the right thing. I know I was in a way, because I was still a kid myself and I couldn't have looked after a kid on my own. They came and sucked it out of me. I was so miserable. I felt guilty, I had just murdered a living thing. Something that was mine was now gone. Robyn took me to her place to have a rest before she took me back to the hostel. I cried myself to sleep.

Paul found out about it and confronted me with it. He said if I'd have told him he would have supported us. That was just what I wanted to hear—if only he had said it before. We got back

together, this time, taking precautions.

Meanwhile, we were still going to church at the hostel. At after-church fellowship I met a lovely couple called Rick and Joyce. Sometimes when the hostel closed on weekends I would go and stay with these people. They lived on the North Shore and really believed in God helping with things. I just thought it was good and bad luck. They had a couple of little boys who were so polite. They helped me a lot with some good advice on things. It was just up to me to take it.

Back at the new hostel we had a new matron (Robyn had only been acting in the position). She was a bitch. She tried to fit into Robyn's shoes, but from day one none of us liked or trusted her. She used to have a bottle of spirits in her room and we found it one day. Drinking on the premises was against the rules, for staff as well as boarders. When she found out we knew about it she filled the bottle with water to cover herself. Fights with her became a regular thing. Robyn often ended up in the middle. Somehow the new matron found out about the abortion, and got her revenge by getting me thrown out and Robyn into trouble for supporting me. It was time to move on again.

I moved into a flat with Tracey, one of the other girls from the hostel, and Paul, my boyfriend. I still had my job at the supermarket and things went well for a while. But eventually we fell

behind in the rent and got kicked out.

I had lost a lot of weight because we couldn't afford to buy food. The couple who had befriended me at church came to the rescue, and put me up at their place until the welfare could sort something out. It was arranged for me to go to a house privately run by a few Christians. They were obviously still trying to tell me something.

I was just a boarder there, with no restrictions, but that didn't stop them trying to run my life while trying to save my soul. There was a nice guy there, he was young and we got on very well. We went up to Port Macquarie one Christmas and stayed with some friends of his. We had a really nice time. There wasn't anything romantic between us, though I think he might have liked there to be. He got me a job in the cafeteria where he used to work. He ended up meeting his future wife there. I was happy for him.

I was eighteen and it was time to move on again, this time into a flat at the back of a florist shop where I was working. My boss went on holidays and my flatmate and I had the run of the place. One day she stole all the cash and took off. I never saw her again. So much for that job.

At that point my district officer, who was still looking out for me even though officially I was no longer the department's responsibility, broke all the rules and moved me into her place. The department would have had her hide, if they had known. She was married to a pig of a guy who I didn't like at all. The feeling was mutual. But it was great living there all the same. I had my own

room that was decorated in red and black. It really felt like home, the first time anywhere had since I left my foster parents.

The house got broken into one day while we were at work. The husband, who hated my friends, thought I or they had something to do with it. When I think back, my friends could have done it, they wouldn't have told me. So once again I was moving on. (By the way, I'm still friends with my old district officer, who got rid of her bozo husband and married someone much nicer.)

I moved into another flat with Tracey. We used to go to the local pub on a Thursday night, there we met a group of people we became friends with. I held a party for my nineteenth birthday, everyone turned up and had a great time. It's a wonder we didn't get kicked out. The smell of dope and alcohol would have been enough.

After a while I found the pace of life Tracey liked to live a bit much. We started to fight, our relationship always had been heated. I had been in contact with my real family and seemed to be getting on OK with them. I asked if I could move home, my mum said yes. I met a friend of my brother's, called Jim. Things at home weren't as good as I thought they were going to be. I guess I'd been away too long. Too much water under the bridge.

So I moved in with Jim. The place was like a drop-in centre every night and I got sick of it. We just had no privacy, so we moved into another

flat. Things started to get bad between us. He was playing up on me, so I slept with his brother, to show him how much it hurt. I was in the shower when he came home one afternoon. He asked me to come out, he wanted to talk to me. When I did, the punches started flying. He punched me in the eye, giving me a real shiner. I just threw whatever I could lay my hands on at him and ran out.

I went to a New Year's Eve party that night and got really drunk. When I came home, I was looking to fight him. He said he was so sorry and it wouldn't happen again. It happened a lot of times after that. I was so unhappy I tried to commit suicide by taking Panadol. Jim took me to hospital. I moved away for a while and then we got back together. But he didn't stop playing around even though now I was carrying his baby. My foster mother suggested I move home while I awaited the baby's arrival.

My foster mother was so happy about being a grandmother, she went out and bought a crib, clothes and other things for the baby. I was going for my regular check-ups at the hospital and kept asking for an ultrasound, just so I could see what was inside me. I was so happy, I was twenty-one and looking forward to having my baby. They finally arranged for the ultrasound. After it was done, they asked me to wait because the doctor wanted to see me. She came in and told me my baby had water on the brain. I cracked up. Not my baby, not me.

My aunty came to the hospital to try to work

out what to do. There was just no guarantee at all for the baby's life. I had to decide whether to see the pregnancy out and run a risk for my own health, or have the baby induced and have her die almost straight away. What a choice! They told me that even if she survived, which was very unlikely, she would be a vegetable.

I decided to have her induced. I came back to hospital the following morning and my daughter was born. I held her and cried and told her I was sorry. One of my tears fell on her face, under her eye. It looked like she was crying and made me think, for a minute, that she was alive. I'm glad I had the chance to hold her, though I had some bad dreams about that experience. I called her Amanda.

Jim was staying away and I had to ring him up and ask him to come and see me. He showed up one night, after he had been swimming with his mates all day. He didn't seem to understand that I really needed him now. At the funeral I just wanted to dive into the ground with Amanda. It was the end for Jim and I, he couldn't or wouldn't support me and I couldn't stand his lies any longer. Amanda's death had made the hole already inside me even larger. I was lost.

I wrote a poem for Amanda:

My baby is gone, sweet little Amanda. You meant the world to me, sweetheart, but I couldn't give you the world. You wouldn't have even known who me or Daddy was.

Up there in heaven you're perfect, not how you were when you were with me. You had life inside my womb but you had no brain. Up in heaven you have everything, much more than I could have given you. It wasn't fair that God gave you to me then took you back. I'll love you forever.

I still remember the day you died
All I did was cry and cry
All my love it went with you
You left my life and made it blue
I miss you Mandy, heaps and heaps
I know you're resting sound asleep
Mummy will see you in the sky
I'll be there soon 'cause soon I'll die.

I met a guy who was going out with someone else. Because I couldn't have him, I wanted him. I set about winning him from the other girl. As soon as I had him, I didn't want him anymore. But by then I was pregnant again. Maybe that was what I had wanted all along. I was scared. When I told him, he decided to stick by me.

The first time I told my natural mother I was pregnant, she told me to get rid of it. After one abortion and one stillbirth there was no way this one was leaving me. I was twenty-two and old enough to make my own decisions. I didn't know how my foster mum would take it. I went to her work and told her. She was happy for me, she knew how Amanda's death had affected me. Out

came the crib and baby clothes again.

At the time I was living with my real parents but was booked into Liverpool Hospital to have the baby. As the hospital was closer to my foster parents, when it got nearer the time, I moved back with them. I explained all this to my real mother, who agreed it was the best thing to do. She said to keep in touch and let her know when the baby was born.

I asked my foster mother to come into the labour ward with me. I thought this might help us to get closer to each other. I was in labour for nine hours and Mum didn't leave my side. I had another little girl, as soon as I heard her make a noise I relaxed, she was alive. Then I slept. In the meantime, Mum wouldn't let go of the baby, she was rapt.

I nearly called her Amanda, but I knew I could not replace one child with another. Her name is Natalie, I love her very much. I went back to my foster parents for a while and then the baby's father and I decided to try and be a family for Natalie's sake. The result was I didn't go back to my real parent's place as previously planned. When I took Natalie to visit a few weeks later, my real mum spun out. She said I preferred my foster family over her and told me to go back to them. So I did and haven't spoken to her since, apart from when her mother died and I rang to pass on my condolences.

I had kept in contact with Nan, a full-blood Aboriginal from the Dharug tribe who herself had been given up by her parents as a child. My nan

was born to two cousins of the same totem. Nan's great-uncle brought her up, as according to tribal Law it is wrong for a child to be conceived by parents of the same totem. I guess she understood how I felt. It was at her request that I tried to re-establish contact with my mother, but my mother wasn't interested. I was sad when she died. I was never taught anything about my Aboriginality and Nan was my last link with that.

I still have contact with my mother's sister, who lives close by. I'm sure every time my name is mentioned my mother's blood boils. I don't know who she thinks she is, that she thinks that she can treat me that way. She was the one who dumped me. My foster-mother at least always tried to do her best for me. My mother goes along in life as if nothing bothers her, that's pretty amazing for someone who has wrecked six lives!

Things didn't work out with Natalie's father. I couldn't show him any affection. I was too much in love with my prize possession. Later on he even claimed Natalie was not his child. We had to go through blood tests which proved his paternity. He no longer sees Natalie and she doesn't ask. I'll never forgive the man who tried to deny his daughter.

Natalie now has two younger brothers. Liam is four and Alex is nine months old. Natalie is thirteen and is in the top classes at school, I am

very proud of her. Liam is full of energy, he doesn't stop from the time time he rises in the morning till bedtime at night, but he is gorgeous. Alex is a good baby, yet to develop a personality. I think he'll be the opposite to Liam. The boys' father is currently in prison. He comes home in two years time. He is the best thing that has happened to me, besides my children. We plan on getting married when he gets out, we will be a real family.

My relationship with my foster family has slowly fallen apart. I still talk to my foster mum and dad, and the brother the same age as me, but as far as the rest of the family goes they have shown their true feelings, that I'm not their real sister. It hurts like hell, but I just have to accept other people's hang-ups.

I realise now that I and my natural brothers and sisters have all done well to survive. All my children know who their real mum is and that they are loved. That's more than I had. People tell me what a good job I am doing with my children. I say I am just doing the best I can. I feel proud when they say that, it's nice when other people notice when you are doing well. Despite everything, I have survived.

Magabala Books Aboriginal Corporation is based in Broome, at the south-western edge of the Kimberley region of Western Australia. The publishing house takes its name from the Yawuru word for the bush banana, which disperses its seeds over the landscape. Our organisation spreads the seeds of Indigenous Australian cultures by recording, publishing and promoting Aboriginal and Torres Strait Islander literatures.

Magabala's titles have been shortlisted for and presented with a number of prestigious literary awards and commendations. In 1992, Magabala was awarded the inaugural Black Books award for initiative and achievement in the publication of works by Aboriginal and Torres Strait Islander people.

MORE MAGABALA BOOKS

FOOTPRINTS ACROSS OUR LAND

Short Stories by Senior Western Desert Women

These vibrant paintings and stories of thirteen women from around Balgo and the central desert of Western Australia give an insight into their rich lives across a time of phenomenal change. The stories encompass hunting, collecting bush food, working on the Canning Stock Route, and everything in between.

Shortlisted for the NSW Premier's Literary Awards 1996

NGAY JANIJIRR NGANK
THIS IS MY WORD

Magdalene Williams, edited by Pat Torres

A beautifully illustrated account of the life of Magdalene Williams of the Nyulnyul people. Raised in the confines of Beagle Bay mission in the Kimberley, she was nevertheless constantly exposed to her traditional culture through her elders. Her account of the coming

of missionaries, and the resultant destruction of Law and Culture, is interweaved with the richness and poetry of Nyulnyul stories.

"...contains original paintings of the Dreaming, local photographs, and an extensive Nyulnyul wordlist. These richly augment the book's sense of place and Williams extraordinary personal contribution to remembering and reclamation." **Australian Book Review**

MILES OF POST AND WIRE
Florence Corrigan, as told to Loreen Brehaut

A poignant, insightful and often amusing story of self-discovery in a sometimes ignorant and cruel society. This book also details Florence Corrigan's life as a horsewoman, dogger, roo skinner, goat hunter, cook, and hardworking mother – she has literally never stopped working.

RAUKKAN
Margaret Brusnahan

Margaret closes her eyes to remember a childhood on the Coorong and under the Gossip Tree. A lyrical tapestry of the life of a remarkable woman and poet.

SACRED COWS
Anita Heiss; illustrated by Danny Eastwood

Anita Heiss's hilarious view of white society from an Aboriginal perspective, with marvellous illustrations by Danny Eastwood. The book includes social rituals from the barbecue to the mobile phone.

UNNA YOU FULLAS
Glenyse Ward

Taking us back to Wandering Mission, Sprattie relives the regimented days and mischievous nights. She shares the secrets of mission kids, driven by their longing for family and home. A wonderful companion to *Wandering Girl*.

Shortlisted NSW Premier's Literary Awards 1992

WANDERING GIRL
Glenyse Ward

From a mission upbringing, Glenyse Ward is sent to work as a domestic on a wealthy Western Australian farm. A bestselling and critically acclaimed story of courage in the face of exploitation.

WHEN YOU GROW UP
Connie McDonald, with Jill Finnane

Raised as an orphan at Forrest River Mission, Connie McDonald became a teacher, a missionary in the Church Army and a welfare worker. Right through her career, she kept searching for her place in the world, as she tells in this forthright and moving book.

Shortlisted for the Dobbie Award 1997

"A rebel in search of freedom, she also wants to put her roots down somewhere and find her family. Hers is a story well worth reading."

Koori Mail

A BOY'S LIFE
Jack Davis

The tragic reality of rural Australia in the twenties and thirties: from family life in the timber town of Yarloop, south of Perth, to the strict regime of the Moore River Aboriginal Settlement. Jack Davis, one of Australia's most respected writers, remembers a boy's life.

JINANGGA
Monty Walgar

Jinangga is the remarkable life story of Monty Walgar, a Yamaji man from Western Australia. At ten, he was taken from his parents and placed in Tardun Mission, developing a severe alcohol problem upon release. Several times he was almost killed in drunken accidents and was constantly in and out of jail...until he finally succeeded in staying sober for good.